Joachim Schmid Photoworks 1982–2007

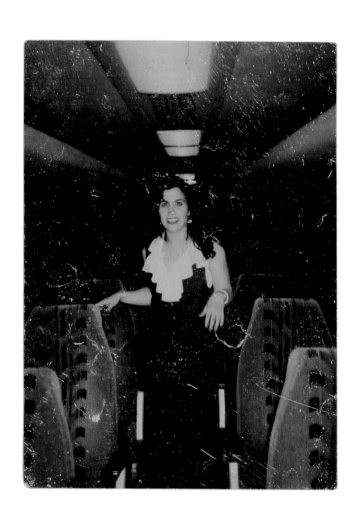

Joachim Schmid Photoworks 1982–2007

Edited by Gordon MacDonald and John S Weber

Photoworks · Tang · Steidl

p3: Bilder von der Straße,
No. 216, San Francisco, March 1994

First edition published in 2007 by Photoworks and
Steidl in association with The Frances Young Tang
Teaching Museum and Art Gallery at Skidmore College,
Saratoga Springs, New York.

This publication was produced to coincide with the
exhibition *Joachim Schmid Photoworks 1982-2007*,
organised by Tang Museum, Skidmore College, and
showing from 3 February to 29 April 2007.
The exhibition will tour to Nederlands Fotomuseum,
Rotterdam, and the BildMuseet, Umeå, Sweden in 2008.
Joachim Schmid Selected Photoworks 1982-2007, a
special artist's selection for London, is presented at The
Photographers' Gallery from 20 April to 17 June 2007.

© Photoworks/Tang/Steidl
Images © Joachim Schmid
Essays © the authors
Installation views at the Tang Museum by Art Evans

British Library Cataloguing-in-Publication Data.
A catalogue record of this book is available from
the British Library.

ISBN 978-3-86521-394-5

Editors: Gordon MacDonald and John S Weber
Book design: Dean Pavitt at LOUP
Printing and production: Steidl, Göttingen
Printed in Germany

Photoworks
The Depot
100 North Road
Brighton, BN1 1YE
England
T: +44(0)1273 607500
e: info@photoworksuk.org
www.photoworksuk.org

Steidl
Düstere Str. 4
37073 Göttingen
Germany
e: mail@steidl.de
www.steidl.de

The Frances Young Tang Teaching Museum
and Art Gallery at Skidmore College
815 North Broadway
Saratoga Springs, NY 12866
USA
e: tang@skidmore.edu
www.skidmore.edu/tang

This publication is funded by the Tang Museum,
through a grant from The Andy Warhol Foundation
for the Visual Arts; by Nederlands Fotomuseum,
Rotterdam; BildMuseet, Umeå, Sweden;
The Photographers' Gallery, London and Photoworks.

Contents

9 Foreword

11 **Joachim Schmid and Photography:** The accidental artist
 John S Weber

21 **Bilder von der Straße**

61 **The Elusive Author:**
 Found photography, authorship and the work of Joachim Schmid
 Stephen Bull

71 **Archiv**

97 **Matters of Life and Death:**
 The immersive aesthetics of Joachim Schmid
 Jan-Erik Lundström

103 **Erste allgemeine Altfotosammlung**

113 **Photogenetic Drafts**

127 **Statics**

149 **The Predator of Images**
 Joan Fontcuberta

157 **Arcana**

173 **Very Miscellaneous**

189 **Joachim Schmid's Very Miscellaneous**
 Val Williams

193 **Decisive Portraits**

207 **Sinterklaas ziet alles**

221 **The Long Walk**
 Frits Gierstberg

227 **Belo Horizonte, Praça Rui Barbosa**

243 **Cyberspaces**

255 **Tausend Himmel**

271 **Books**

288 Acknowledgments & Biographies

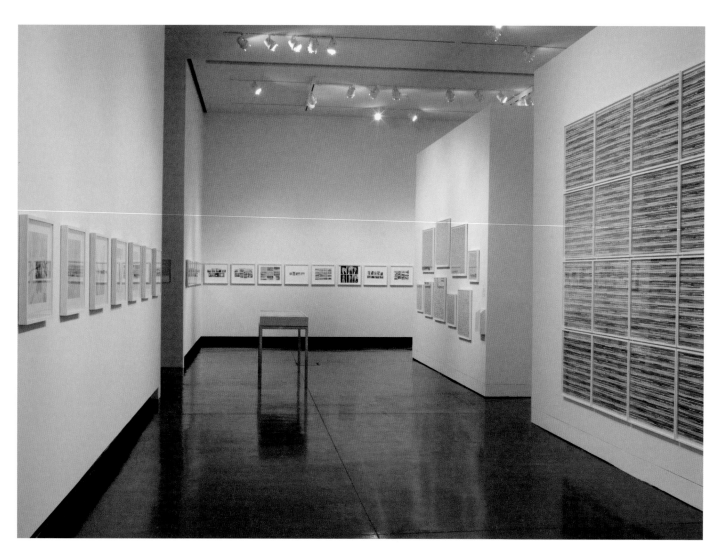

Installation view, Tang Museum,
Skidmore College, 2007.

Foreword

The work of Joachim Schmid remained something of
an inside secret in photography throughout much of the
1990s, despite over a decade of international exhibitions
and numerous publications. But by late 2004, it was
clear to those involved in this project that Schmid's
contribution to the field deserved wider recognition,
critical assessment, and documentation. By happy
coincidence, the Tang Museum's plan to spearhead a
Schmid travelling retrospective occurred simultaneously
with discussions between Photoworks and Val Williams
about the need for a book following up on the 1996
collaboration, *Very Miscellaneous*, to document the full
range of Schmid's achievement. In short order, the partners
found each other. The result includes two exhibitions
and this book, which together offer the first in depth
view of Schmid's original and distinctive work.

Plans for the travelling exhibition, *Joachim Schmid
Photoworks 1982–2007*, solidified in Berlin at the time
of the *1st Berlin Photography Festival* in September 2005,
when Frits Gierstberg and the Nederlands Fotomuseum
became the first confirmed project partner. Festival
curator Jan-Erik Lundström, who had included Schmid
in the Berlin show, soon expressed his interest in bringing
a Schmid survey to the BildMuseet in Umeå, Sweden. In
February 2006, meetings in London hosted by Val Williams
at the London College of Communications cemented a
unique collaboration between the three exhibition venues
and Photoworks to produce a major book on Schmid,
also titled *Joachim Schmid Photoworks 1982–2007*,
designed to coincide with the exhibitions. At the same
time initial contacts with Brett Rogers and Stefanie
Braun at The Photographers' Gallery laid the groundwork
for their participation. Created collaboratively between

The Photographers' Gallery and the Tang Museum,
Joachim Schmid Selected Photoworks 1982–2007 offers a
complementary look at Schmid's work, featuring a special
artist's selection for London and the premiere of new
work created for that venue.

This book, *Joachim Schmid Photoworks 1982–2007*,
was conceived as neither a traditional exhibition catalogue
nor an illustrated critical monograph, but a blend that
takes the best from each format. Thanks to generous
contributions from all participating exhibition venues and
a grant from the Andy Warhol Foundation for the Visual
Arts, it has been possible to publish a critical mass of
images from Schmid's massive series *Bilder von der Straße*
and *Archiv* for the first time, complemented by equally
representative selections of his other major series.
Essays by Stephen Bull, Joan Fontcuberta, Frits Gierstberg,
Jan-Erik Lundström and Val Williams situate Schmid's
ideas and approach historically, opening avenues for
future scholarship and critical assessment of both
Schmid's work and the domain of found photography
itself. Gordon MacDonald's professional guidance, insight,
and timely interventions as editor and project director
have been indispensable, along with the excellent and
responsive contributions of book designer Dean Pavitt.
Our publishing partners, Steidl, and especially our
colleague Michael Mack, have brought to the printing
of the book all the benefit of their professionalism and
unwavering attention to detail, and have also ensured
that it has a truly international status and distribution.
Finally, Joachim Schmid himself has been the most
engaged, committed and flexible artist collaborator
we could have hoped for. Together we thank him and
all of the partners who have made this multifaceted
international project possible, including the dedicated
and resourceful staffs of Photoworks, the Tang Museum,
Nederlands Fotomuseum, BildMuseet and The
Photographers' Gallery.

David Chandler
Photoworks
Brighton, England

John S Weber
Tang Museum,
Skidmore College
Saratoga Springs, USA

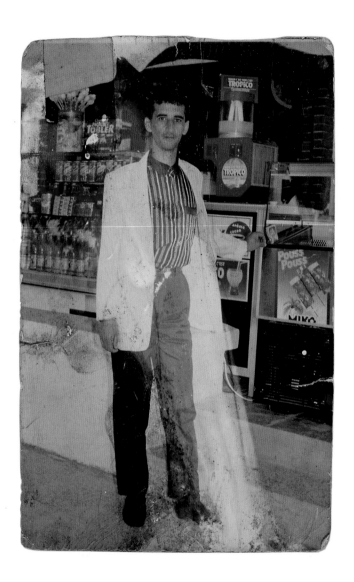

Joachim Schmid and Photography:
The accidental artist

John S Weber

Joachim Schmid suspects that few people in the world have looked at more photographs than he has. It is a surprising and untestable assertion, but he is probably right. 'For several years – the late 1980s to mid-1990s – I was a professional looker. I looked at thousands of photographs a day. I once checked it: I could look at about 10,000 in a day. But after you finish that you just want to close your eyes. No more visual information.'[1] At the time, he was working on archive commissions, both as an artist and as an editor-critic, combing through mountains of material in search of unseen patterns, undiscovered themes, exceptional images, and new ways to understand photography outside the museum walls. Driven by the conviction that 'basically everything is worth looking at', his work since 1982 has burrowed deeply into the photographic 'Bilderberg' of everyday life,[2] extracting a mother lode of insight into the life and death of photographs in our time.

This book, the essays and images in it, and the two exhibitions that coincide with its publication offer the first opportunity to assess the full range of Schmid's work with found photographs. The results are visually beguiling, often hilarious, and deeply moving on a human level, constituting one of the most sustained and original investigations of vernacular photography yet created. Collectively, Schmid's work blurs the boundaries between artist, critic, historian, archeologist and anthropologist in a radical re-reading of the history of photography. He asks viewers to look seriously at photographic material formerly considered unworthy of either the art museum or archive, including discarded snapshots, Brazilian ID photographs, purloined images from internet webcams, and eccentric groupings of vernacular photography. At once expanding and short-circuiting inherited notions of the photographic canon, his work deftly questions the nature of authorship and artistic intention in the post-romantic, post-Duchamp western tradition.

At its heart, Schmid's work expresses a quiet but persistent skepticism about the central role assigned to art photography and what we might call 'high journalism' as documents of human photographic culture. Without disputing the value of accepted histories and collections of photography, Schmid chooses to focus on what they leave out, and what those other scorned and neglected images reveal about the world of cameras and people. He appreciates historical figures such as August Sander and Robert Frank, but finding a snapshot that looks

Bilder von der Straße,
No. 414, Paris, July 1996

1 Joachim Schmid, in conversation with the author, 24-26 May 2006.

2 The term, 'Bilderberg' [Mountain of Pictures] comes from the title of a book edited by Schmid, *Ins Innere des Bilderbergs*, drawn from the photo archive of Berlin's Hochschule der Künste. It is also a deliberate riff on Thomas Mann's *Der Zauberberg* [The Magic Mountain].

unnervingly similar to a Sander or Frank nestled in a cardboard box at a flea market intrigues him even more than the 'real thing'. And most of all he's curious about what other kinds of photographs he can find in the same box. In recent years, his curiosity has led him to the computer, the internet and their joint reinvention of the photographic universe. In each case, the overriding issue for Schmid is not individual genius or the singular masterpiece – whether discovered on a museum wall or in a pawn shop – it is the nature of the medium itself and what emerges when millions of cameras in the hands of millions of people produce literally billions of images.

In 1989, during celebrations for the 150th anniversary of the invention of photography, Schmid provocatively proclaimed 'No new photographs until the old ones have been used up!' He was only half-serious, but he was also only half-joking, as Bilder von der Straße [Pictures from the Street], Archiv [Archive], and Photogenetic Drafts soon made abundantly clear. As discussed by Joan Fontcuberta, an aesthetic of salvage and recuperation runs through most of Schmid's projects; however, Schmid's attitude toward his material is visual rather than scientific, and playful rather than preservationist. He has charted photographic typologies both ubiquitous and exceptional, yet he has no desire to archive everything photographic for its own sake. He regards his work as commentary first and foremost, not as collecting; in anthropological terms, he considers himself a 'gatherer' who assembles what he needs and then discards the rest, rather than a 'collector' whose instinct is to hoard, catalogue, and protect everything he finds. 'If people knew how many photographs I have thrown away, they would be shocked.'[3]

It is easy to misread Schmid's work as pure social science, or as pure art. In fact, it is neither. His carefully choreographed sequences of anonymous photo fragments rescued from the brink of destruction, exhumed from obscure photo archives and the recycling bins of mass media, emerge impure and hybrid – a Frankenstein's Monster of photographic history, a buried past that was never expected to rise and walk again. And like the creation of Mary Shelley's prototypical mad scientist, Schmid's reanimated monster proves profoundly, heartbreakingly human – emotionally unguarded, shocking at times, and alive against all odds.

Monstrous or not, Schmid's artworks frequently present themselves outwardly like visual anthropology,

photographic criticism, or straight photographic history, and with good reason. His career as an artist evolved slowly and in many respects accidentally out of his practice in the early 1980s as a critic, essayist, and publisher. Schmid had moved to West Berlin in 1977 after finishing national service as a paramedic, enrolling at Berlin's Hochschule der Künste with the faculty for design and visual communications, where he studied with Herbert Kapitzki. During this time he was one of the group that founded die Tageszeitung, the nationally distributed, alternative, left-wing daily newspaper based in Berlin. In the early 1980s he began writing criticism and essays on photography for European Photography and other publications. He enjoyed criticism and quickly established himself as a talented young writer with original, often contrarian views on all things photographic. In 1982, confronted with a backlog of unpublished manuscripts, Schmid founded his own self-published and virtually hand-made journal, Fotokritik.

Available primarily by subscription, Fotokritik became a vehicle for Schmid's own writing and that of other German-language, non-academic critics of photography. Its circulation was small, but influential. Schmid often devoted individual issues to particular topics (for example, museums of photographic history in Germany), and announced exhibitions, events, and news of interest to the field. As part of this work, Schmid began collecting photographs from flea markets,[4] systematically clipping intriguing images from the popular press, and assembling groups of pictures that might eventually form the basis for an article or an issue of the journal. At the time, Schmid saw his activity as criticism and had no thought of becoming an 'artist-critic'.[5] Nevertheless, the seeds of Bilder von der Straße and Archiv belong to this period, and mirror Schmid's original work as a critic and commentator on photography.

As the 1980s progressed Fotokritik came to function less as a forum for traditional criticism and more as a hybrid of artist's project and visual anthropology journal. In his own writing, Schmid found that he had said much of what he had to say, while his collecting activity had taken on a life of its own. By the latter half of the decade, Schmid had begun publishing selections of his snapshots, clipped newspaper photos, personal ads, and other photographic ephemera as small, short-run artist's books with no critical writing accompanying them. Looking back

3 Joachim Schmid, in conversation with the author, 24–26 May 2006.

4 In the 1980s and 1990s, Schmid lived two blocks from one of Berlin's largest flea markets, held every weekend on the Straße des 17. Juni. Visiting it every week and getting to know the vendors provided him with access to a rich vein of vernacular photographic material, particularly snapshots and family albums that came up for sale.

5 Joachim Schmid, in conversation with the author, 24–26 May 2006.

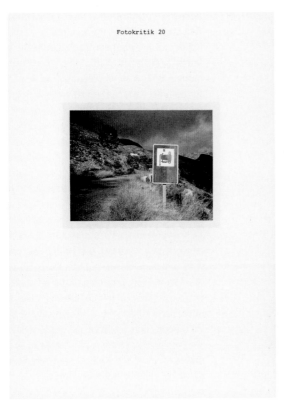

Fotokritik 20

Cover of *Fotokritik* No. 20, 1986

on this period of transition today, Schmid is alternately bemused and fascinated: 'I had noticed that the material was much richer than what I was writing about it. Eventually I said, let's just present the photographs as they are.... That raises interesting questions about what the artist actually does and the question of authorship. A lot of American artists started with the question, and then made the artwork. It was the other way around with me. I had the stuff without deciding whether it should be art or not.'[6] Exhibitions followed, and without precisely planning it, Joachim Schmid had become an artist.

Although Schmid decisively jumped ship from critic-editor to artist in the late 1980s, it would be wrong to regard his later career as a kind of counter-scholarship pursued under the guise of art, or an attempt to redress the art historical record from within. His intersecting creative and critical impulses, to the extent that they can be isolated from one another, are investigative and at times ironic, and a spirit of exploration motivates Schmid more than any historical plan or preconceived political mission. Yet, as Stephen Bull argues convincingly in his essay here, Schmid's attitude towards his material is elusive, and as Schmid himself observes, his role as its 'author' is shifting and hard to place. His work is as much about finding, analysing, and organising as it is about making, and to the extent that it is 'made,' much of the making was done by other people. In comparison to other 'post-modern picture jockeys,' to borrow Frits Gierstberg's delicious phrase, Schmid's impact on his photographic raw material feels surprisingly hands-off, despite the fact that it entails a great deal of careful editing and visual decision making en route to exhibition. Regardless of those interventions, what viewers first perceive is the richness of the material itself, for Schmid has proven uncannily good at getting his hands on original photographic images of great intensity and quantity. And this lends the work its human density, the sense of hundreds of lives present in unmediated photographic form.

Schmid's individual pieces regularly offer an unexpected trove of overlooked and undervalued images, yet the conceptual and philosophical questions they provoke are equally fascinating. For example, it would be possible to situate Schmid's *Cyberspaces* within a long body of documentary photography dealing with prostitution, strippers, carnivals, circuses and similar subject matter. His decision to keep the ostensible subject of the images

6 ibid.

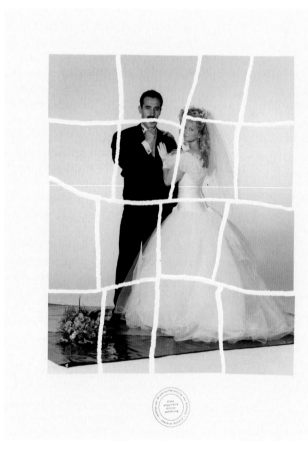

Untitled photowork, 1993

off camera – or rather, off webcam, to be precise – nevertheless speaks to a fundamental difference in attitude between Schmid and his photographic fellow travellers – a pessimism, perhaps, about what photography can and cannot truly claim to discuss in good faith. What, after all, could blurred, pixelated images of a line-up of internet prostitutes teach us about their real lives, or ours? And are there not compelling moral reasons to avoid further exploiting their images under the banner of art? Implicitly, Schmid's evacuated online sex sites question the motives of anyone who points a camera at anyone else for personal gain. This selling and showing of pictures is an unseemly business, he seems to say, even if all parties are complicit and consenting. Such questions run through all his work without resolving into a single, consistent pattern.

Given the ethical delicacy of *Cyberspaces*, it is intriguing to consider a work such as *Photogenetic Drafts*, which presents images pasted together from the bisected, discarded negatives of a commercial photo studio. Schmid received the negatives as part of his project, *Erste allgemeine Altfotosammlung*, for which he promised 'environmentally sound recycling of old photographs.' They were sent to him cut in half, undoubtedly to keep them from being reprinted. Although, strictly speaking, Schmid did indeed 'recycle' the negatives as promised, he undoubtedly did not do it in the way the studio expected. Whether he was on firm legal grounds or not, the work involved appropriating for his own ends images made by others for other purposes, a condition governing virtually everything he has made, and applicable to any artist working with found photographs. That said, in comparison with *Cyberspaces*, the raw material for *Photogenetic Drafts* seems to arise from a less charged set of power relationships between photographer and photographed, money and control. Arguably, this bestows upon Schmid a greater degree of moral wiggle room in finding a new purpose for the negatives he was offered. However, not all would agree, and this moral ambiguity becomes part of the work, a fact Schmid acknowledges and accepts.

Schmid's engagement with art and photography began in an early encounter with the work of Andy Warhol, one of art history's paradigmatic image appropriators. In 1971 as a teenage exchange student in Stockholm, he had dashed into the Moderna Museet to escape from a sudden downpour, stumbling into an extensive installation of the Pop artist's work. The idea that art could be made from an

Cyberspace #23, 2004

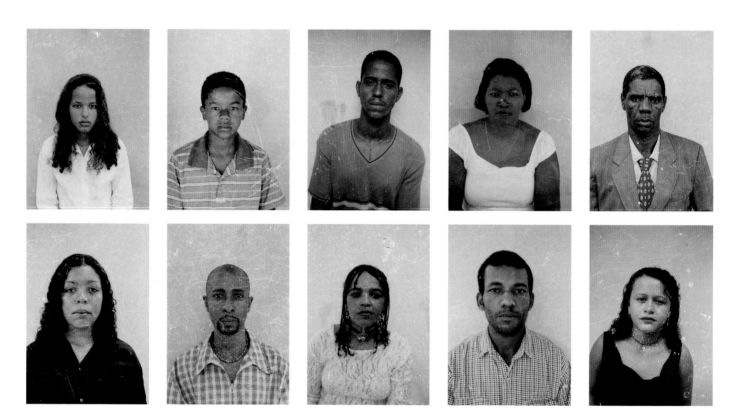

From: Belo Horizonte, Praça Rui Barbosa, 2002

image of a coke bottle, a soup can, or a news photo retained its radicality and shock value in the early 1970s, particularly for a sixteen-year-old West German boy from the provinces. Schmid considers this revelation a turning point in his life, the first time the notion of modern art, or being an artist, entered his consciousness. What most impressed Schmid was the use of images from the mass media, particularly the car crashes, and the nondescript character of many Warhol silkscreen paintings from the mid-1960s. Early on, Warhol offered Schmid a model of artmaking grounded in the appropriation and recycling of photographs, and encouraged him to look at ordinary things in new ways, things no one else had chosen to consider as art.

Rolf Sachsse has discussed the nature of Schmid's immersion in a sea of other people's images in *Archiv*,[7] and Stephen Bull traces Schmid's refusal to offer up artistic self-expression as we normally understand it.[8] Even when he makes personal appearances, as in the short, non-fiction novella he wrote to chronicle *Erste allgemeine Altfotosammlung*, Schmid conveys little sense of his own personality. It would be inaccurate to say that he is hiding, however, for he has regularly inserted himself into the work in a variety of surreptitious ways. His own baby picture appears in one of the panels of *Archiv*, and close observers can find here and there the image of himself and his wife, Angelika Theuss, secreted anonymously amidst its hundreds of photos and panels. Nevertheless, these images tell us little about the artist in the end, beyond the already obvious fact that he possesses an active and often subversive sense of humour.

Schmid's work with vernacular photographs emerged in a period from the mid-1970s to the early 1980s that saw an international upsurge of interest in snapshots, photo archives, photojournalism, art photography, and the broader role of photography in culture. Susan Sontag's *On Photography*, published in 1977, was immediately translated into German and influenced Schmid's subsequent writing and thinking. In Berlin, the late 1970s also witnessed a series of notable exhibitions by Dieter Hacker and Andreas Seltzer that focused on amateur photography, documented by their journal, *Volksfoto*. Work such as Larry Sultan and Mike Mandel's *Evidence* was known, if not widely available. The image appropriations of emerging art world favourites such as Cindy Sherman, Sherrie Levine, Richard Prince and Barbara Kruger were

also familiar to Schmid by the early 1980s, although he recalls an interest only in Kruger at the time.

The artist's project that seems the most relevant to Schmid's concerns, Gerhard Richter's *Atlas*, was in fact not known to him until after he had begun work on *Archiv*. And while the two projects share a superficial similarity, their differences are instructive. Richter's immense compendium of postcards, news photos, clippings, and his own snapshots functions autobiographically and artistically in a way utterly unlike Schmid's work. Although it exists as an artwork in its own right, *Atlas* also serves as raw material for Richter's paintings, an outgrowth of the constant tension between photographic image and abstraction in that artist's work. In contrast, Schmid's *Archiv* examines photography taxonomically, socially, and at times satirically as a practice in and of itself.

In 1988, shortly after announcing the end of *Fotokritik*, Schmid founded Edition Fricke & Schmid together with another Berlin artist, Adib Fricke. Over the next decade, the Edition published books and multiples by both artists, and occasionally by others. In the same year, one of Schmid's first exhibitions as an artist was mounted by Blue Sky Gallery in Portland, Oregon, USA, a non-profit, artist-run photography space. Tellingly, two of Blue Sky's founders, Christopher Rauschenberg and Terry Toedtemeier, had published *Drugstore Photographs* in 1977, documenting highlights of their own snapshot collections.

In the years that followed, Schmid embarked on the commissioned archive projects, installations, serial pieces, books, and conceptual projects that make up his oeuvre. The central tensions between artist, critic, anthropologist, and historian mark each of them in distinct ways. Each piece and project represents both an actual, material pathway of photographic history, and also proposes yet another on-ramp to that history. Schmid's commentators, including those in this book, have mapped these tensions insightfully and in detail. But there remains another less noted characteristic of his work, a politics that is subliminal, yet seldom absent.

In varying degrees, nearly everything Schmid has done appears anti-monumental and egalitarian, a stance that philosophically unites Schmid's work as a whole. Both politically and economically, he has consistently avoided the capital intensive, commercial gallery route that art photography took in the 1990s, as photographs came to rival the scale and cost of paintings in the art market.

7 Rolf Sachsse, 'Joachim Schmid's *Archiv*,' *History of Photography*, Volume 24, Number 3, Autumn 2000, pp255-261.

8 See Bull's essay in this book. It is also worth noting here the parallel to Warhol's practice and the surface impersonality of Warhol's work.

His work rests instead on small components and gestures that accumulate emotional intensity and visual scale only when combined. As Schmid observes, 'five pictures from the street are rather uninteresting, but fifty are interesting and five hundred are extremely interesting. The quantity adds to the quality.'[9] Studied carefully, a small ID photo from *Bilder von der Straße* or a sad mug shot from *Belo Horizonte* delivers everything that can be asked of portrait photography. They are complete, anonymous gems that play havoc with the very notion of 'masterpiece', its necessities of size, rarity and expense. In effect, Schmid dares and invites viewers to find their own similar masterpieces, whether underfoot or in grandmother's photo album. In this scenario, neither artist nor gallery is truly necessary.

Schmid considers this stance and the work it generates implicitly political, but rarely comments on the subject unless asked in interviews. Nevertheless, it is no accident that he worked on an alternative newspaper as a young man, and no coincidence that his artistic subjects encompass working class Brazilians, black American GIs in the Second World War, and very ordinary people in Britain, Germany, and other countries where he has worked and travelled. Without crusading or proposing solutions to social problems, his work reflects social histories, and does so out of social conviction.

For related reasons, many of Schmid's most significant pieces exist, as he puts it, 'at the fringes of the museum and gallery world.'[10] The size and thirteen year production timeline of *Archiv*, for example, made it virtually unmarketable by most galleries, yet it was produced inexpensively. His native tendency to work small and incrementally was reinforced during trips to Brazil, where he met artists who felt constrained by a lack of resources. In contrast, working in a modest studio with small-scale components, Schmid has found the freedom to create whatever he chooses without worrying about whether it will sell beforehand, or needing to change course after the fact if it doesn't.

In recent years, Schmid's studio has increasingly moved onto the internet and into the computer as photography has become more and more a matter of onscreen pixels rather than on-the-street prints. Schmid sees projects such as *Bilder von der Straße* and *Archiv* as products of a twentieth century analogue photographic culture that has already come to an end, regardless of how long its vestiges linger. The virtual, non-material nature of digital, onscreen images has altered his practice, in some cases dramatically and counter-intuitively. For example, reproduced in small scale in a book, the webcam screen-grabs of *Cyberspaces* betray far less of the highly pixelated, degraded qualities so evident in Schmid's 50 x 60cm exhibition prints. As with photorealist paintings, the screen-grab works must be seen in person to be fully appreciated. In other recent pieces such as *Tausend Himmel*, Schmid has begun to experiment with digital displays for digitally generated images, accepting the new technological laboratory of the photograph as a valid means of public presentation.

Within German photography itself, Joachim Schmid's work echoes, extends, and then challenges a tradition of taxonomic analysis and long-term, serial projects. This tradition encompasses Karl Blossfeldt's *Urformen der Kunst* [normally translated as Art Forms in Nature], August Sander's *Menschen des 20. Jahrhunderts* [People of the Twentieth Century], and more recent photographers such as Bernd and Hilla Becher and their students Thomas Struth, Candida Höfer, Thomas Ruff and others. Although he clearly shares much with these predecessors and contemporaries, Schmid's contribution to photography has been made in a spirit of principled dissent from the dominant tradition. In setting out to examine everything photographic beyond art photography, Joachim Schmid accidentally became an artist himself. Looking back over twenty-five years of his work, one is struck again and again by how much he has seen in places where others saw nothing, and how differently he has looked at things that were always in plain view.

9 Joachim Schmid, in conversation with the author, 24-26 May 2006.

10 Ibid.

From: Orte und Zeichen. 629
Bilder für das 21. Jahrhundert
[Places and Signs. 629 Pictures for
the 21st Century], multichannel
digital photo installation, 2007

John S Weber Joachim Schmid and Photography: The accidental artist

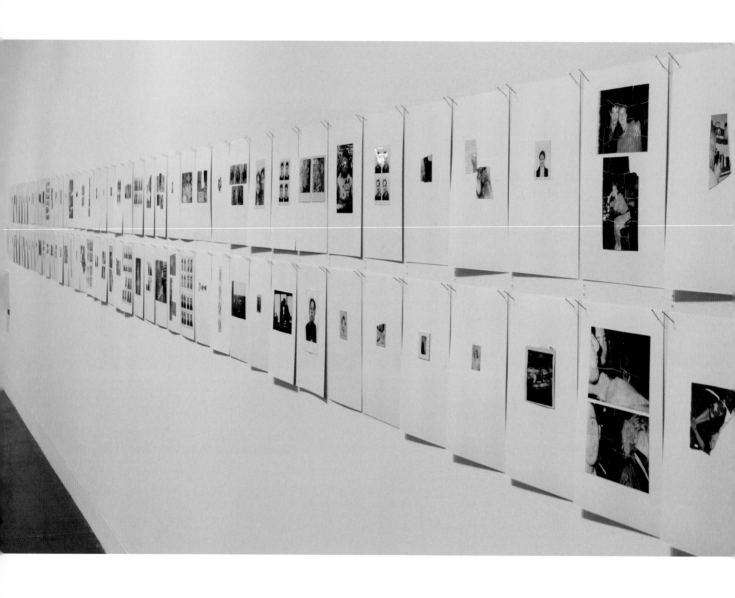

Bilder von der Straße

The first thing likely to strike viewers of *Bilder von der Straße* [Pictures from the Street] is that the photographs themselves are utterly and unexpectedly fascinating, both as visual artefacts and human documents. The second thing is that these snapshots, ID photos and photobooth discards aren't really art at all and were never intended by their makers to be seen in a public exhibition. But, since 1982, Schmid has found and collected nearly nine hundred photographs that were formerly lost, thrown away, driven over, torn up, walked on, soaked by the rain and faded by the sun. They now form a sprawling conceptual artwork that ironically redefines the accepted genre of fine-print 'street photography' and stakes a claim as far as possible from nearly everything photographic that has yet made it into a museum or onto an art gallery wall.

Bilder von der Straße is Schmid's longest-running project to date, and it remains arguably the most radical piece he has ever produced. It is conceptually crucial that *Bilder von der Straße* encompasses *all* the photos Schmid has found since 1982, hung in chronological sequence according to when they were found. He does not edit the series according to aesthetic criteria, preferring to offer an unbiased, sociological sample of photos lost or thrown away by their owners. Although he finds some images more intriguing than others, Schmid has strenuously resisted all attempts to break up the series and show or sell it along artistic or thematic lines. Too large now to be easily exhibited in its complete form, the series is typically sampled on a random, numerical basis to fit available exhibition spaces, with a minimum of at least one hundred panels on view. In this way, Schmid preserves the conceptual spirit and effect of his original, show-it-all methodology.

1 Joachim Schmid in a talk given at the Tang Museum, Skidmore College, 24 May 2006.

Nearly all of Schmid's street photos depict people, and more than half of them have been ripped to pieces. He has commented on the violent energy these tiny image fragments still contain, and it is impossible not to read torn figures such as the nude woman in *No. 192, São Paulo, October 1993*, as desperate attempts to purge memory. The bitterness left behind by a failed romance is overcome by destroying all photographic evidence of the former lover, in what the artist refers to as 'a kind of voodoo-like ritual.'[1] In a society that relies on photographs to archive memory, remembrance cannot be banished as long as the photos survive. This belief, so apparent in *Bilder von der Straße*, underscores the deep-seated psychological role photography plays as an expected, almost compulsory accompaniment to modern human relationships – whether professional, familial or intimate.

Specific images in *Bilder von der Straße* suggest particular stories, but none of them can be read with any certainty. A strangely-coloured portrait from Hamburg (*No. 1, Hamburg, August 1982*) and a magnificently eroded black and white photo from Berlin (*No. 111, Berlin, August 1991*) suggest ID cards or passports and evoke rites of passage, such as school, or the administrative presence of the state and employer in the life of the individual. One unusual image, *No. 82, Berlin, July 1990*, is apparently also an ID photo of a young boy. On the right hand side of the picture is an ominous dark shape, which on closer perusal reveals itself as a duplicate of the boy's image, only upside-down. The photograph's somewhat crude, black-and-white quality carries romantic but disquieting overtones. Is this an orphaned refugee, or simply a worried schoolboy? A similar mystery is evoked by *No. 140, Belo Horizonte, August 1992*, a torn image of a young girl at the edge of the ocean. Was this slightly over-exposed snapshot thrown out on account of poor photographic technique? Or did it find its way onto the street after the breakdown of a marriage? *No. 75, Berlin, May 1990* shows a man and woman reflected in a mirror. The man's hand rests on the woman's shoulder in a proprietary, even sinister manner. He is smiling. She is not. A series of cosmetic containers project phallically up from the bottom of the photo. To the left of the mirror hangs a wooden bamboo rod. Are we looking at a married couple or two lovers horsing around the bathroom, or was this document created by some psychotic snapshooter in preparation for something far worse than a few playful Polaroids?

Intervening in the life of these images, Schmid has recuperated them as testimony to the extended imprint left by photography on the modern city and modern life. Beyond that, *Bilder von der Straße* also tells the story of his own peripatetic urban travels for two and a half decades as lecturer, teacher, critic, artist, and image scavenger. Each picture is labelled according to the time and place he found it, thereby serving as a route-marker in Schmid's journey as an international photo-flâneur.

In this sense, Schmid is indeed the artist behind *Bilder von der Straße*. Yet by including every photograph he finds, Schmid deliberately explodes the notions of personal style and expression that we normally associate with art and photography. This in turn points to the peculiar dual register on which *Bilder von der Straße* operates: it is simultaneously a sophisticated *commentary* on our obsession with photography, and a *collection* of images visually seductive in their own right.

Where the viewing of most works of art leads to speculation concerning the intentions of the artist, that speculation is here transferred and dispersed. These photographs are riddles cast out from the lives of the people they depict, and their secrets have nothing to do with Joachim Schmid, conceptual artist, former critic, publisher and one-time photographer. Each picture represents a narrative the viewer can sense, but not reconstruct. Like all photographs, they are decontextualised fragments – frustrating, but at times beautiful in the mute way they activate and tantalise the imagination.

Approached as a whole, *Bilder von der Straße* is a genuine *Salon des Refusés,* an anti-museum of throwaways, an archaeological sweep through the streets of modern life. Simply by picking up what other people have dropped on the ground, Schmid has compiled a sprawling, evocative, disturbing, hilarious, utterly familiar, yet uncanny artwork of simple means and surprising depth. In refusing to play the photo-auteur, Schmid has told a far more ambitious story about the life and afterlife of photographs.

John S Weber

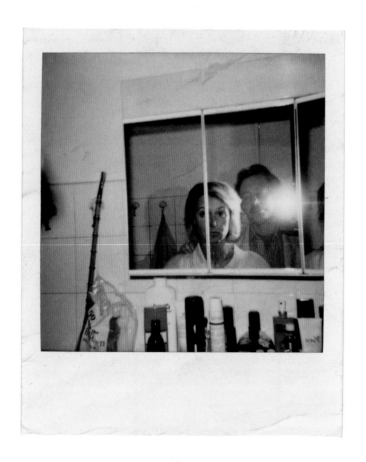

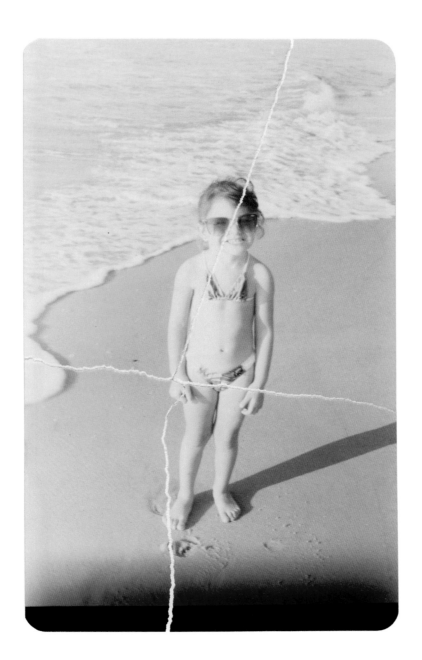

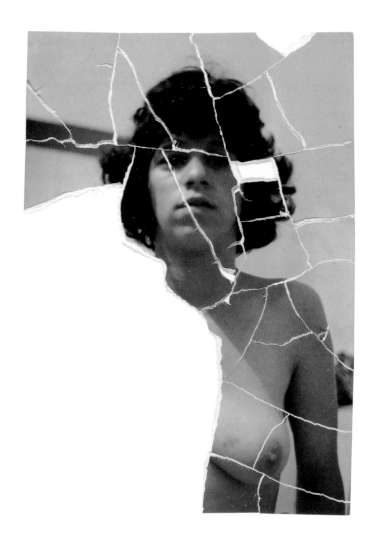

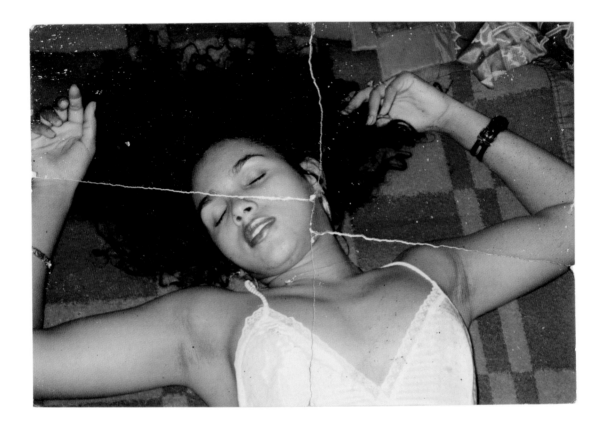

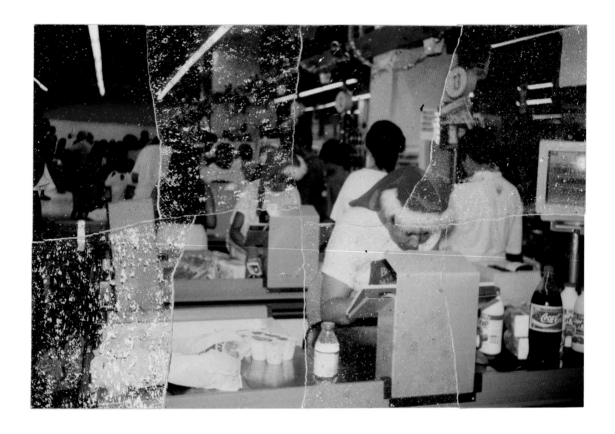

The Elusive Author:
Found photography, authorship and the work of Joachim Schmid

Stephen Bull

Who is Joachim Schmid anyway? Identifying a consistent author in the work that Schmid has made during the last three decades is not easy. The association between authorship and photographs is complicated enough, but when confronting artworks based on found photographs, locating artist and intention becomes even more difficult. Whilst discussing exhibitions of his early and ongoing series *Bilder von der Straße*, Schmid has said, 'I ('the author') don't know more than anybody in the audience'.[1] Note the quotation marks around 'the author'. Schmid is well aware of the elusive nature of his position in anchoring the meaning of the images. With his projects over the last twenty-five years Schmid has played a game of hide and seek. Sometimes his role as author is not at all apparent, at other times his presence is far more obvious. Rarely is it consistent from project to project. In fact, there is no better illustration of the uneasy affiliation that found photography has with authorship than the work Joachim Schmid has made since he stopped taking photographs and started taking other people's in the early 1980s.

The title *Bilder von der Straße* evokes the classic idea of a skilful photographer plucking decisive moments out of the miasma of modern life. Actually the series is a continuous document of every lost or discarded photograph that Schmid has picked up off the ground since 1982. Each image is numbered and the location, month and year of the find are recorded. If a photograph has been torn up, Schmid will laboriously search for all the pieces so that he can reassemble as full a picture as possible. Although some parts of the photograph may remain undiscovered, as in *No. 629, Berlin, November 1999*, where a girl, apparently laughing, is three fragments short of completion.[2]

Even if the picture is all there, any authors remain absent. When *Bilder von der Straße* is shown in galleries Schmid himself offers no ideas as to what is happening in the images. It is up to us to decide what motivated the man to record himself with a Polaroid camera placing a hand on the shoulder of a worried-looking woman staring into a bathroom mirror (*No. 75, Berlin, May 1990*), or to figure out just how that scratched and stepped-on picturesque landscape came to be lost (*No. 187, São Paulo, September 1993*). As John S Weber notes in his perceptive introduction to the 1994 book of the project, with *Bilder von der Straße*, 'Schmid deliberately explodes the notions of personal style and expression that we

1 'Very Miscellaneous' Joachim Schmid interviewed by Val Williams, *Insight*, February 1998, p7.

2 The laughing girl may not be laughing. This is only my interpretation based on the hint of an extended lower lip, half closed eyes and raised eyebrows still visible around the voids where some of the discarded pieces evaded Schmid's search.

normally associate with photo authorship.'[3] Seen in exhibitions, even Schmid's editing and ordering of *Bilder von der Straße* cannot be taken as a clue to his own beliefs about the meanings of the photographs. Before each show, Schmid requests exhibition organisers to send him a randomly chosen list of numbers, with the plan that in return they will receive the appropriate images to be exhibited in strict numerical sequence. Sadly curators have always disregarded this idea and instead designed their show based on how many photographs will fit into the space of the gallery.

Schmid's other major early project, one that started in 1986 and remained in progress until the end of the millennium, is the vast *Archiv*. For this work Schmid's rationale expanded dramatically. All vernacular photographs were up for grabs as he trawled postcard racks, magazines, second-hand stalls at markets and any other places where the pictures that constitute the majority of photographic production are available in abundance. Then came 'Institut zur Wiederaufbereitung von Altfotos' [The Institute for the Reprocessing of Used Photographs], an official-sounding agency whose leaflets appeared in several newspapers and magazines asking people to send in their unwanted prints for environmentally sound recycling. This was of course a ruse by Schmid, a way to get photographs to come to him. Much to his surprise the images arrived in their thousands, as readers were moved enough by the timely ecological tone of the advert to part with their unwanted pictures. Some of the photographs Schmid received were recent, but others were made as far back as the early 1900s - a whole history of photography arriving in the post.

Schmid was true to his word. He did recycle the photographs, just not in the way that those who sent them to him expected. Instead he added them to *Archiv*, furthering the project's cataloguing of everyday photography in the twentieth century. For *Bilder von der Straße* the rules were simple, every photograph found was incorporated sequentially into the work. But with *Archiv* Schmid's impartial approach changed. Editing became a necessity; it was impossible to include everything (although even getting rid of the surplus images led to other projects, some being disposed of in the rubbish for *Erste allgemeine Altfotosammlung* in 1991, others shredded and reassembled into compound abstracts to form the later series *Statics*). In 1998,

towards the end of the *Archiv* project, Schmid described his criteria for choosing from the mass of photographic imagery he acquired: 'I've been selecting and editing photographs according to their similarity. Photographs with similar/identical motives, aesthetic features, etc. are arranged in groups on panels and then these panels are themselves arranged in groups. The entire project consists of about seven hundred panels. It's an analytical survey of international vernacular photography throughout the course of the century. The work simultaneously contributes to and subverts academic photo-history.'[4]

This statement, from an interview with Val Williams, is rare in that Schmid confesses his aims for the project. But within *Archiv* itself he does not offer up any specific interpretation of the images. Thus the viewer is left only with the panels of photographic 'species' to contemplate: for example, the trend for seafarers posing for holiday snaps alongside ships' lifebelts throughout the twentieth century; the apparently universal urge to record the stroking of horses' heads in fields; or the consistent inclusion of scantily clad girls lying amongst the waves on postcards of Paphos.

Although Schmid made selective decisions in the creation of *Archiv*, any authorial bias remains covert. Nevertheless, across Schmid's numerous projects certain recurring themes have been discerned. Joan Fontcuberta, for instance, has recently argued that, 'All of Schmid's work is governed by a spirit of visual ecology: there is an excess of images in the world, therefore instead of contributing to that super saturation we should impose on ourselves a task of recycling, of salvage among the residue.'[5]

The emphasis Fontcuberta places on photographic overproduction echoes points made in 1991 in 'No More Photos, Please!', one of the first major articles to be published about Schmid's work. Within the piece, loosely based around a discussion with Frits Gierstberg, Schmid suggests that we have too many photographs and that we need only re-use those that already exist. 'This is why I never take any holiday photos', Schmid reasons, 'I find them instead.'[6] 'In fact', Schmid says at the conclusion of the piece, 'everyone who still walks around with a camera is suspicious: he or she hasn't learnt anything from history!'[7]

Gierstberg highlights a mischievous aspect of Schmid's oeuvre that comes to the fore in *Meisterwerke der Fotokunst* [Masterpieces of Photography], made two

3 John S Weber 'Joachim Schmid: Anti-Auteur, Photo-Flâneur', *Bilder von der Straße*, Edition Fricke & Schmid, 1994, p14.

4 'Very Miscellaneous', p6.

5 Joan Fontcuberta 'Archive Noise', *Photoworks*, No.4, May/October 2005, p65.

6 Frits Gierstberg 'No More Photos, Please!', *Perspektief*, No.41, May 1991, p59.

7 ibid. p61.

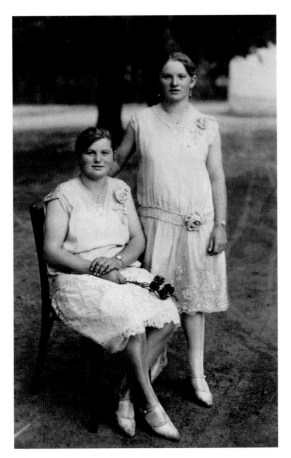

8 Stephen Bull introduction to
Joachim Schmid Photoworks
1982-2002, Vigo, 2002, p9

9 Gierstberg op.cit. p61

years earlier in collaboration with another Berlin artist, Adib Fricke. With *Meisterwerke der Fotokunst* Schmid takes the unprecedented step of identifying the authors of the photographs we see. The thing is: those named are not really the authors. It is this series more than any other that prompted me to call Joachim Schmid 'a thief and a liar' when introducing his work for a more concise monograph published in 2002.[8]

The *Meisterwerke* portfolio contains images plundered from the collections of amateur snapshooters that could, at a pinch, pass for the work of canonical artists and photographers. Seen together with the caption *Ansel Adams, Yosemite National Park, 1956*, that fine-grained, rocky mountain valley with a full tonal range just might be a lost *f*64 classic. The apparently Parisian street scene where a man smiles through the window of a shoemaker's workshop certainly makes for a convincing Atget. Perhaps Harry Callahan really did photograph 'Eleanor's sister' in 1958. And a layered, doubled image of clouds and a woman holding a camera that Schmid and Fricke have dated 1937 just might represent René Magritte's brief foray into photomontage. The estate of Magritte thought so, too, and made a failed financial claim on any sales of the picture.[9]

As with all found photography, the context for *Meisterwerke* is essential. The discourse that Schmid and Fricke surround the photographs with is what finally creates the confidence trick that takes us in. An old black and white image of two young women posing outdoors, one seated, one standing, pictured straight on, their expressions ambiguous, is attributed by Schmid and Fricke to August Sander. I first saw this picture on a postcard in the Serpentine Gallery's bookshop, in London, in the early nineties. Reading the text on the reverse, 'August Sander, Middle Class Twins, 1924', I was assured of its authenticity and only discovered the truth months later, that it had not been a Sander I had previously missed. In addition to the captions, the *Meisterwerke der Fotokunst* portfolio also comes with a complimentary text by a sham Helmut Gernsheim to further cement the legitimacy of the images. The series is full of wry photography in-jokes (such as the 'aerial view' of a dog supposedly by László Moholy-Nagy), but it also makes serious points about the apparatus through which photographic history creates and canonises some authors above others and links certain styles and subjects indelibly to particular names.

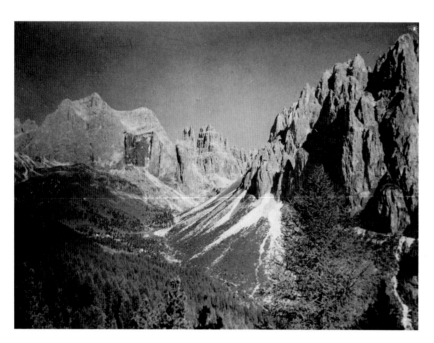

10 See 'List of Most Expensive
Photographs' in Wikipedia
en.wikipedia.org/wiki/list_of_
most_expensive_photographs
(accessed 17 August 2006).

11 Peter Jerrome, Chairman
of the Petworth Society, has
pointed out to me that many
of the portraits in the George
Garland Collection were in fact
taken by Garland's assistants;
prompting us to note again the
unreliability of authorship in all
forms of photography (unpublished
interview with Peter Jerrome,
Petworth, 24 April 1996).

Issues relating to the provenance of photographs are even more relevant now than when *Meisterwerke der Fotokunst* first appeared, with vintage prints such as Edward Steichen's 1904 pictorialist image *The Pond – Moonlight* fetching a record auction price of $2,928,000 in early 2006.[10] Schmid's meddling with ideas of attribution, together with the suggestion that an amateur snapper in the right place at the right time can create a 'masterpiece', makes for a salient reminder of the fragile nature of authorship when it comes to any photograph, found or otherwise.

It is ironic, then, that what appears to be one of Schmid's most autobiographical projects was the first one to use photographs made by a known (and genuinely credited) photographer. In 1996, as part of their *Country Life* project, Schmid was commissioned by Photoworks to work with the archive of pictures made by George Garland from the 1920s to the 1960s in and around the small English village of Petworth in Sussex. Garland was a professional photographer whose work encompassed portraiture, agricultural images and landscapes. For his commission Schmid selected studio portraits made by Garland between the late twenties and early fifties.[11] They are often rather bland examples; most were probably made for identity cards. But far more than in any previous project, Schmid recontextualises the images, authoring the work to a greater extent than ever before. In the book and exhibition of the project, the portraits are accompanied by stories extracted from contemporaneous local newspapers. Schmid took the unusual step of photographing the newspaper texts using a narrow depth of field to convey the idea of fading memories: only certain lines being focused enough to be fully legible. When exhibited, the texts and images are scattered across the gallery wall, meaning, for instance, that the few words visible from a story about a funeral might be linked by the viewer to the nearby photograph of a fresh-faced fellow, or equally connected to other adjacent images such as an older lady in a buttoned up overcoat, or a girl with pigtails and dark eyes. In turn, the young man might also have been present at the dance reported in another story, or perhaps even involved in the court case described elsewhere.

Because *Very Miscellaneous* draws heavily on texts and images from the 1940s, it is inevitable that many of the stories and associations make reference to the war. Some of the sitters wear badges with military connections

such as RAF wings. That Schmid chose to focus on these years is significant. Although it is not explicitly referred to in any of the texts selected, Petworth was the scene of a tragic wartime incident where the local boys' school was bombed by a German plane, killing all of the pupils inside. But Schmid has resisted the reading of *Very Miscellaneous* as being his 'obligatory German history piece'.[12] This is understandable coming from an artist who has successfully dodged many of the clichés of authorship. Nevertheless it is hard not to see the project as far more personal than Schmid's previous work, where the possibilities of what can be done with found photographs are explored from an amused distance.

The theme of loss (which is almost always an aspect of work using found photography) seems to linger heavily in *Very Miscellaneous*. Most of those portrayed will have known and perhaps even been related to the victims of the bombing. This grim reading is reinforced by the work's passing resemblance to Christian Boltanski's dimly illuminated 'altarpieces', often made using faces enlarged out of found group portraits from the 1930s of those likely to have died during the war. As Val Williams suggests, *Very Miscellaneous* stands out from previous projects as 'a much darker work'.[13] That said, Schmid still slips in a few lighter moments, such as the amusing title (which he came across scribbled on a box of Garland's pictures), and a reference to the 'incomprehensibility' of modern art appearing in one of the newspaper texts. The in-jokes have not disappeared entirely.

Very Miscellaneous was the first of three commissions that Schmid undertook in Britain in the late 1990s. In 1998 he went on to work with the *Daily Herald* picture archive in Bradford creating *The Face in the Desert*. This became both a public artwork and a newspaper format publication that combined press pictures from the archive with the backs of those prints, which were found to be awash with palimpsests of stories and annotations. Like the text panels in *Very Miscellaneous*, the reports add another 'voice' to Schmid's work. The 1950 *Daily Herald* item from which the title of the project originates tells a story that parallels Schmid's own practice: a British soldier in the Middle East discovers a page from an English newspaper in the desert and, seeing on it a photograph of a girl, successfully makes contact with her back home (the full story remains slightly obscure, as part of the newspaper column pasted to the print's reverse has been torn off).

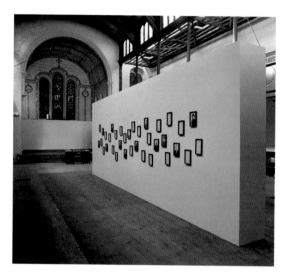

Very Miscellaneous at Fabrica,
Brighton, 1997 (photo: Jim Cooke)

12 'Very Miscellaneous' p9.

13 ibid. p6.

Towards the end of the decade, around the time of *The Face in the Desert,* an increasing tendency to ventriloquise a personal commentary of sorts through other people's words becomes apparent and Schmid's authorial presence subtly increases. Nevertheless, any texts actually written by Schmid to accompany books and exhibitions remain matter of fact.

The third commission was an invitation to respond to the permanent collection of the Pitt Rivers Museum in Oxford. Schmid intervened by cheekily inserting twentieth-century postcards into the museum cases of ancient artefacts: 1950s cards of a bejewelled Marilyn Monroe, for example, are propped up alongside a display of stone beads. With this project Schmid also set up a narrative between different cultures, again contextualising and authoring the found images to a far greater extent than in a series such as *Archiv.* The title Schmid chose for the Oxford intervention was *The Joachim Schmid Collection at the Pitt Rivers Museum,* the eponymous nature of which suggests the desire of private collectors to increase the value of their possessions through public exhibitions. As well as this, the title inevitably places further emphasis on Schmid as the named author of the work.

The proliferation of commissions that 'responded' to archives in the 1990s, and the commissioning of Schmid to make his own particular response, are indications of found photography becoming a more established part of art practice in that period (and of Joachim Schmid as a key practitioner of the art). Although the use of appropriated photographs to create new work is as old as photography itself - and was of course a vital element in movements such as Dada, Surrealism and Pop Art - it is only during the last thirty years that working with found photography has become fully accepted as a practice in its own right.[14]

1977 is a punkish 'year zero' for found photography. Over those twelve months a number of important events for the practice happened: Dick Jewell published his seminal small book of discarded photo booth pictures that he had discovered in, around and on top of booths since 1968. (Indeed it seems quite likely that the title of Jewell's publication, *Found Photos,* may be the earliest recorded example of the now familiar term.)[15] Also in 1977, Larry Sultan and Mike Mandel published their book *Evidence,* a larger and altogether more lavish affair than Jewell's pocketsize volume. Amongst other things, *Evidence*

demonstrated how a photograph could be taken from an archive belonging to, say, the Jet Propulsion Laboratories, Pasadena, and then be placed on a gallery wall and in an art book context to be viewed as a compelling, aesthetically sophisticated image. And in that same year Richard Prince extracted four advertisements for interiors from a *New York Times* Sunday supplement, rephotographed them and exhibited the series in a gallery - the first of many such works that Prince has continued to create.

Prince was of course only one of a number of American artists incorporating techniques of rephotographing, restaging and recontextualising photographs into their work in the late seventies. Sherrie Levine, Barbara Kruger, Cindy Sherman, Frank Majore and many other practitioners were also beginning to appropriate photographic imagery to their own ends. Again during 1977, Douglas Crimp curated *Pictures* at the Artists Space in New York, which included Levine's work and that of other practitioners using appropriation. Crimp and writers such as Rosalind Krauss and Craig Owens linked the emerging work to postmodern theories, including Roland Barthes' idea of the death of the author, where, briefly, the meaning of a work does not lie in the biographical details of its named creator (the 'author-God'), but is formed instead from the culture in which it was made and is therefore open to interpretation from the viewer, significantly referred to by Barthes as 'the reader.'[16]

Reports of the death of the author turn out to have been greatly exaggerated. In 2006, Prince's *Untitled (Cowboy),* one of his iconic eighties images cropped and enlarged from a Marlboro advertisement, sold for $1,248,000 at auction, joining Steichen's *The Pond – Moonlight* in the top ten most expensive photographs. It might seem odd for an appropriated photograph to achieve such recognition by the market. In fact, Prince's images are highly authored, with a clear central theme evident throughout his work: stripping bare the American mythologies of figures such as cowboys and half-naked biker chicks through selection and pairing of their images. Importantly, Prince deals with the same themes in his related paintings. Although during the 1980s commentators such as Abigail Solomon-Godeau saw Prince as rejecting 'traditional notions of authorship,'[17] the artist himself described the technique of rephotography as 'a physical activity that locates the author behind the camera, not in front of it, not beside it and not away from it. There's a whole lot of authorship going on.'[18]

14 See Stephen Bull 'Other People's Photographs', *Creative Camera*, No.344, Feb/Mar 1997.

15 The term 'vernacular photography' has also come to be used to describe the same practice, see Val Williams, 'Lost Worlds', *Eye*, No.55, Spring 2005 and the entry on 'Vernacular Photography' in Wikipedia en.wikipedia.org/ wiki/Vernacular_photography (accessed 1 September 2006).

16 Roland Barthes 'The Death of the Author', *Image/Music/ Text*, Fontana, 1977.

17 Abigail Solomon-Godeau, 'Playing in the Fields of the Image', *Photography at the Dock: Essays on Photographic History, Institutions and Practices*, University of Minnesota Press, 1991, p96.

18 Richard Prince interviewed by Peter Halley in *ZG*, No.10, 1984, p5.

The modern construction of the author has not left us and can be as present in work using found photography as anywhere else. Even the wanderings of Schmid, documented all the way through the last twenty-five years via the locations recorded by *Bilder von der Straße*, suggest that most modernist of figures, the *flâneur*. More recently Schmid's voyages and observations were recorded in even greater detail through his 1998 project *Sinterklaas ziet alles*. This set of one hundred and eighty index cards (some featuring images, others texts), all exhibited in postcard racks and also available in a box, was commissioned by the Mondriaan Foundation and Nederlands Foto Instituut, Rotterdam. Many of the picture cards reproduce images seen by Schmid in European cities: London, Paris, Berlin and in Rotterdam itself. Some of these are photographs that Schmid may have picked up, such as a flyer for a London club night, but most of them seem to be images from papers or magazines that have caught his eye. Each photograph is dated in more detail than *Bilder von der Straße*; exact days and months are recorded, all of them lying between 1996 and 1998 (the period of the commission) and presumably referring to the date they were discovered. The precision of this dating could therefore suggest the found photography equivalent of the 'decisive moment': in this case the point at which Schmid as the 'author-God' skilfully selected the photograph.

The texts, too, are accompanied by a location and date from the same time span, but the exact nature of these texts is less clear. Some seem to be direct observations of events seen by Schmid on his travels, for example: 'A woman around seventy, bent over with white hair and a cane; she is wearing a long pleated white skirt and walks over a subway ventilation shaft. Practically in unison three passersby call out, "Hello Marilyn!" Everyone laughs. Berlin, July 17, 1997' Other texts comment on events, such as the media coverage of the death of Diana, Princess of Wales. Some record conversations, either overheard or told to Schmid, including a tale related by 'G.' in Bradford on 13 August 1998 (presumably while the artist was working on *The Face in the Desert*) about a photograph of a naked man playing with a rubber duck, discovered inside a toilet roll in a restaurant bathroom.

Though varied, the photographs picked out by Schmid in *Sinterklaas ziet alles* are generally those mediated via some form of mass reproduction: no one-off snapshots here. Across the texts themes of looking and the relationship

From: Menschen und Dinge. 853
Bilder für das 21. Jahrhundert
[People and Things. 853 Pictures
for the 21st Century], multichannel
digital photo installation, 2006

between fiction and reality are prevalent, such as the inability to see a woman in a white skirt crossing a subway vent as anyone other than the ubiquitous Monroe (who I've already mentioned once in this essay) as she appeared in the film *The Seven Year Itch*. The diaristic application of images in *Sinterklaas ziet alles* results in a far more authored piece of work than even *Very Miscellaneous*, and the text cards supplement this with writings that often seem to be Schmid's own. *Sinterklaas ziet alles* is therefore a sort of panoptic personal journal, maybe even a Westonian *Daybooks* of found photography.

One of the tales recounted in *Sinterklaas ziet alles* tells of the protagonist's investigation of the web after 'even good friends, ones whose opinions I can usually trust, begin to spin fantastic tales about the Internet'. If this is Schmid talking, then the date on the card (24 January 1996) marks the beginning of a direction in his work that has continued to develop in the first decade of the new century. Now that the idea of finding pictures in the street has become commonplace in photographic practice and digital cameras have meant that unwanted images are usually deleted rather than discarded, Schmid has chosen another road to go down in his search for photographs: the information superhighway (as it was called when familiar metaphors were still needed to describe the nascent net to us). Out of Schmid's virtual travels came the 2004 series *Cyberspaces*: stills grabbed from commercial sexcams, appropriated to draw our attention to the artificiality of the scenes prepared for pornographic activity. Unlike Thomas Ruff's recent blurred-out appropriations of internet porn, Schmid's series confronts us with the empty sets in the raw: stark and pixelated.

Schmid's most recent project using the web is *Menschen und Dinge. 853 Bilder für das 21. Jahrhundert* [People and Things. 853 Pictures for the 21st Century]. An *Archiv* for the new millennium, *Menschen und Dinge* consists of Googled images classified into twenty-two sections, including all the participants in the 2006 Miss World contest and every tie in the catalogue from which Schmid orders his own neckwear. Despite the autobiographical element of the latter example, the series is a return to the hands-off approach of much earlier projects. In his recent use of pictures from the web Schmid's personal input has once again receded, the anonymity and distancing effect of the net restoring a detachment to Schmid's work.

But then there is *Tausend Himmel* from 2005, a digital loop of photographs that were actually made by Schmid himself. (Isn't he ashamed? Has he forgotten 'No More Photos, Please!'?) Each picture in the series shows the sky, sometimes quite cloudy, sometimes quite clear, and often very beautiful. A helicopter flies through many of the photographs. Schmid is well aware that it is impossible for any of us to look upon images of aircraft in the sky without thinking of 9/11; nevertheless the work also has an individual meaning for the artist. A few years ago Schmid suffered from an acute hearing problem, the effects of which made any sound unbearable to him. The noise of the helicopters that regularly flew over his house became torturous and so Schmid took to shooting them with his camera as a kind of photo-therapy (it didn't matter if occasionally he missed, the sound was still there in the sky). Oddly, many of the cloudier images are also reminiscent of Stieglitz's *Equivalents*, the pictures that represent the acme of modernist photography's attempts to express the author's emotions through the camera. Once again Schmid oscillates between roles: a distanced curator of photographs in one work, an expressive photographer in the next.

So who is Joachim Schmid? Thankfully it's hard to say. The ebb and flow of authorship across Schmid's projects means that as soon as we catch a glimpse of the artist he vanishes. This is just the way it should be. As Schmid well knows, authorship has its uses. But one of the great strengths of found photography is that it can provide an escape from the fixation of meaning through biographical attribution. Joachim Schmid, the elusive author, has successfully and creatively exploited this aspect of found photography in the work he has made during the last quarter of a century.

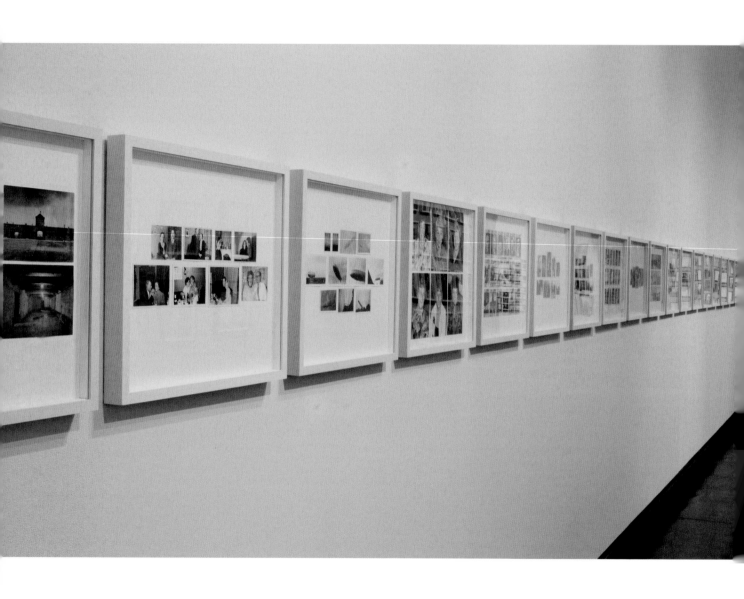

Archiv

Using four similar postcards showing a fabled beach in Cyprus,[1] depicted both with and without a female model in a bathing suit, Schmid assembled the first panel of *Archiv* [Archive] in 1986, when he was still active primarily as a publisher and critic. He concluded work on the series in 1999, seven hundred and twenty-five panels later. The individual panels contain anywhere from two to sixty images and the entire series encompasses literally thousands of pictures, sorted by Schmid into idiosyncratic but revealing categories and image genres. It is at once a history, a commentary, and a celebration of the mundane weirdness of commonplace photography. Like *Bilder von der Straße*, *Archiv* seems to take seriously the ironic motto the artist coined at the time of photography's 150th anniversary in 1989: 'No new photos until the old ones are used up.' And like *Bilder von der Straße*, it lavishes attention on precisely the kinds of photos that museums and historians long ignored.[2]

Schmid considers *Archiv* 'a survey of photography in the twentieth century with some fields missing, like art photography, fashion, and journalism – everything that somebody else cares for.'[3] Its source material encompasses both vernacular snapshot photography from anonymous sources and examples of the lowest grade of commercial photography. Using a standard 40 x 50cm matt board as the basic frame, *Archiv* sorts photography into a series of concise, carefully composed, freeze-frame typologies. Schmid has said that he sees each panel as representing a 'species' of photograph – an idea taken from natural history collections rather than from art history. In the same breath he observes ironically that since there are no clear species in photography, 'I do have the opportunity to prove that elephants are directly related to mosquitoes.'

Humour aside, Schmid's taxonomy is anything but arbitrary. His canny image groups are constructed with a careful modulation of form and content that balances the

psychological as well as the purely visual on the page. Rarely does too much information overwhelm the theme. And rarely, if ever, does it take longer than a flash to see and accept what Schmid is proposing.

Looking at the range of panels in *Archiv*, what becomes clear is the simultaneous eccentricity and validity of Schmid's curious historical taxonomy. Many of the image groupings are immediately recognisable: people with dogs; team pictures; wedding couples with flowers; postcard views of motels; sports celebrity headshots; the new car; dinner with the family; and so on. Other 'species' Schmid identifies are unanticipated in their photographic specificity, yet equally recognisable as typologies we have seen before without registering them: women and children with horses and ponies; people with TV sets; airplanes photographed from airport windows; elephants in the zoo; people in rowboats, non-descript urban plazas. Such pictures are endemic to snapshot photography, the dimestore postcard rack, and the vacation albums of the industrialised, capitalist world. However, their use remains fundamentally private in nature, and therefore hidden. To have seen such photos means, typically, to have come across them in one's own family. Yet it is one thing to see a picture of girls and horses in your grandparents' photo album, and a different matter entirely to find essentially the same image reproduced by others. It reveals a commonality of human photographic instinct that is poignant, unexpected, and ultimately somewhat unsettling.

In the visual record provided by *Archiv*, specific and private individual experiences aggregate as shared photographic habits. The resulting taxonomy first spotlights and then refutes any attempt to use photography to capture 'unique' experiences and enthusiasms, and thereby craft personal history and identity. *Archiv* teaches us that if you can do it with a camera, someone else is already doing it, too, and has been for decades. This lesson is perhaps most evident in the snapshot panels of *Archiv*, but it is fundamental as well to the panels displaying commercial photographs.

Even as it deconstructs the ideology of 'the Kodak moment,' *Archiv* offers a fascinating portrait of everyday pastimes and common desires. Its psychological range encompasses the breadth of human experience, including satire, irony, and a sense of the absurd. Filled with sentiment and cliché, *Archiv* itself remains unsentimental, observing its subjects from a vantage point well above the photographic fray, analysing, organising, and occasionally snickering with olympian delight.

John S Weber

1 According to Classical legend, Venus, the Goddess of Love, emerged from the ocean on the beach at Paphos, depicted in the first panel of *Archiv*.

2 Since the 1970s at the latest, a number of historians and photographers began to take an interest in many of the kinds of material important to Schmid, particularly the snapshot. In West Germany, the *Volksfoto* exhibitions and publications of Dieter Hacker and Andreas Seltzer were of particular interest to Schmid, as was Susan Sontag's *On Photography*. Schmid's work can be seen in part as both a response and an intensification of that initial flurry of interest in vernacular photography. Yet the depth of Schmid's engagement with it has exceeded that of both his forebears and contemporaries.

3 Unless otherwise noted, all quotes are taken from a lecture by Schmid at the Tang Museum, Skidmore College, 24 May 2006.

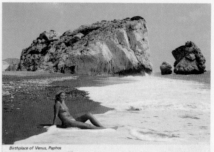

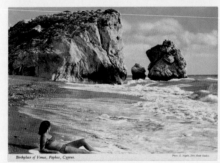

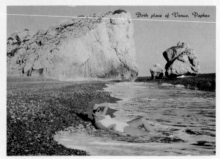

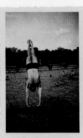

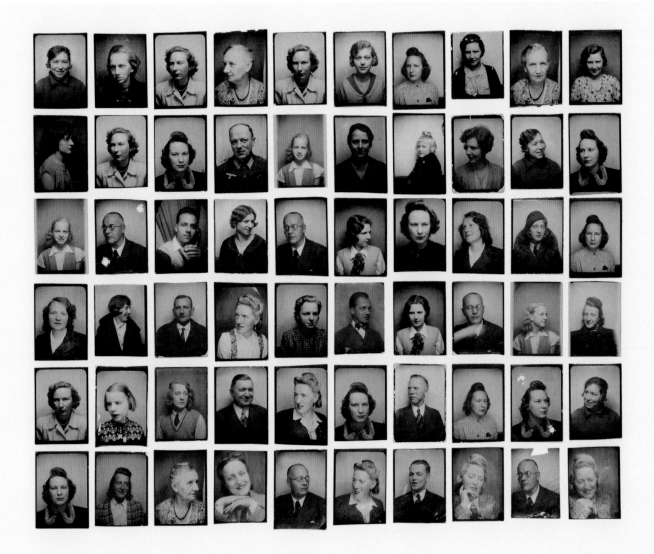

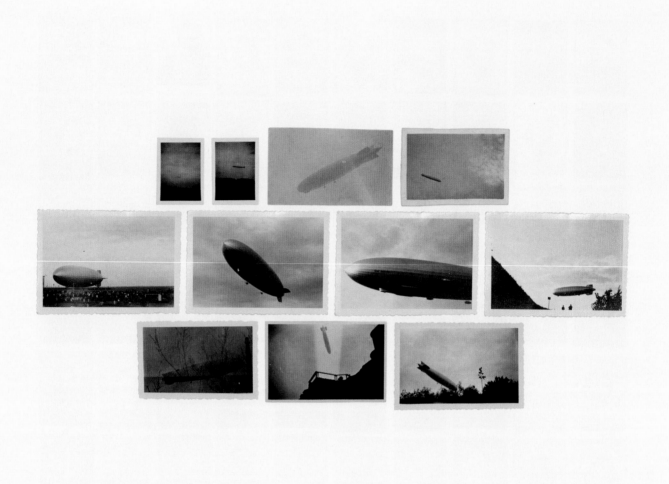

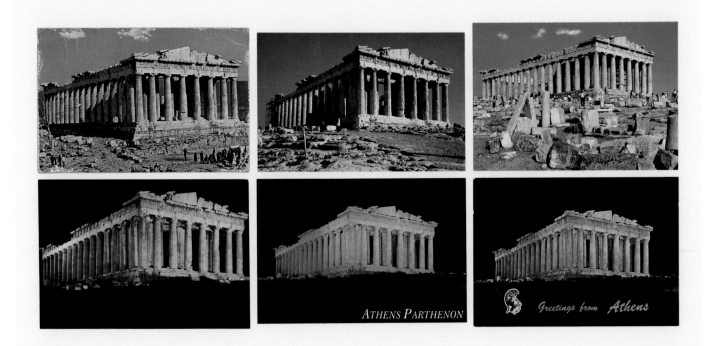

"MEU SOBRENOME É CAMPANÁRIO"

TONINHO CAMPANÁRIO
VEREADOR - Nº 41661 - PSD

VEREADOR
WALDIR
DA COSTA GOMES
N: 45644

PSDB

MAURO MATIAS

SEU
COMPANHEIRO
DE LUTA

PARA VEREADOR
33635
PMN

SURETTE 25653
VEREADOR

César Masel
Nº 45.649
VEREADOR - PSDB

Prefeito: AÉCIO NEVES

VEREADORA
Nº 33699

PMN/PDC BHM

E P/ PREFEITO DE BH
33 WELLINGTON DE CASTRO

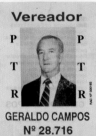

Vereador
P T P T
R R

GERALDO CAMPOS
Nº 28.716
B.H. EM BOAS MÃOS

VEREADOR
PFL
Nº 25.699

VOTE COM
CARINHO,
VOTE EM
PASSARINHO

EMERSON VELOSO CORDEIRO
Vereador 92
14635

Saúde - Educação
Criação Do Hospital Geriátrico
Prefeito: Paulo Heslander
Apoio: Deputado
Bené Guedes

VOTE 15616

PAULO ALKMIM
VEREADOR 92 - BH PMDB

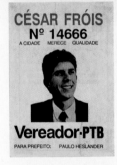

CÉSAR FRÓIS
Nº 14666
A CIDADE MERECE QUALIDADE

Vereador·PTB
PARA PREFEITO: PAULO HESLANDER

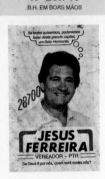

Se todos quisermos, poderemos
fazer desta grande capital,
um Belo Horizonte.

28700

JESUS
FERREIRA
VEREADOR – PTR
Se Deus é por nós, quem será contra nós?

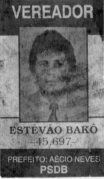

VEREADOR

ESTÊVÃO BAKÔ
-45.697-

PREFEITO: AÉCIO NEVES
PSDB

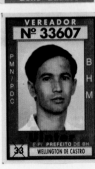

VEREADOR
Nº 33607

PMN/PDC BHM

E P/ PREFEITO DE BH
33 WELLINGTON DE CASTRO

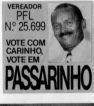

VEREADOR
Levy Ramos

Nº 15.616

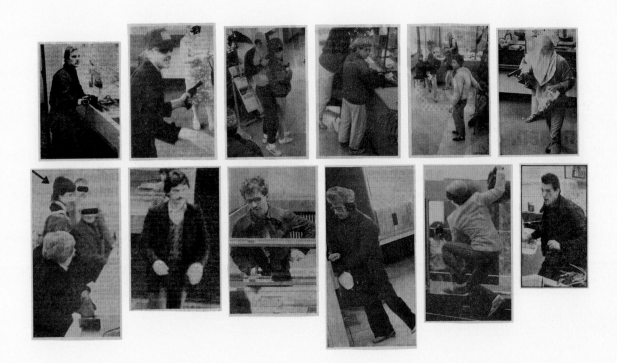

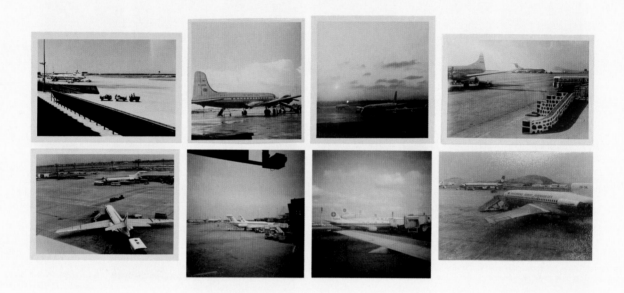

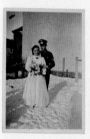

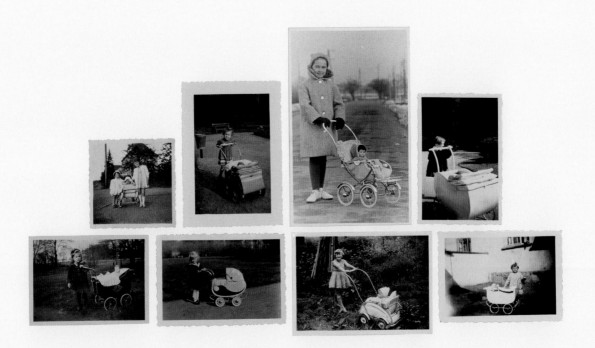

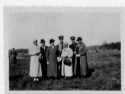

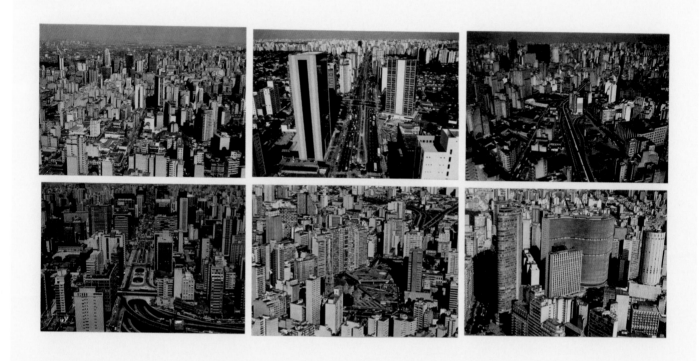

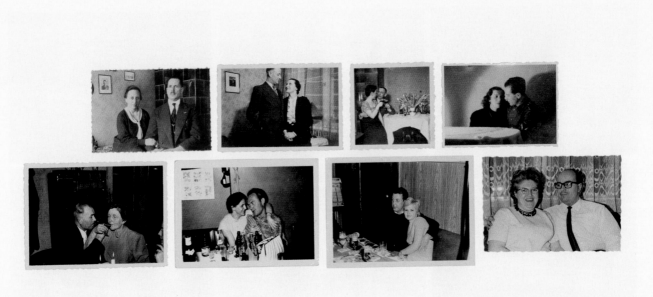

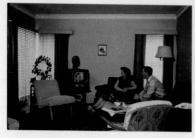

Matters of Life and Death:
The immersive aesthetics of Joachim Schmid

Jan-Erik Lundström

The imaginative powers of an author are the subject of one of Borges' most well-known, perplexing and frequently referenced short stories, *Pierre Menard, Author of Don Quixote*. The philosopher Pierre Menard's interest in and desire to identify with Miguel de Cervantes is so great that he attempts to (re)write the novel *Don Quixote*. Menard's aim is not to produce a translation, new version, or interpretation, but a full word-by-word re-write of the novel in its original seventeenth century language, despite the fact that Menard himself is an early twentieth century writer. And, indeed, after remarkable effort he partly succeeds in producing 'the ninth and thirty-eighth chapters of Part One... plus a fragment of the third chapter'. An unprecedented – and possibly never repeated – feat of conceptual empathy and immersive aesthetics.

Pierre Menard is, alas, a real writer, at least according to Borges, as Borges is a real writer (I think) and Joachim Schmid a real artist (I have met him – Joachim that is – have dined at his home and he is, among other things, well acquainted with the work of 'Joachim Schmid'). But what if Joachim Schmid turned out to be a relative (at least conceptually speaking) of Menard and, in fact (who can claim anything about facts when it comes to photography?), turns out to be the photographer of the photographs that make up his practice? What if Joachim Schmid has staged, invented, directed, realised each and every photograph present in the oeuvre of Joachim Schmid? And if not the entire oeuvre, what if he had sneaked in a few 'originals' (or are they then originals?) in each project? Blended 'found' with 'taken'? Somewhere, in an elaborate but secretive production site, Joachim Schmid is reproducing photographs on an industrial scale, has established a factory aimed at faking found photography, at generating photographs impossibly and seamlessly close to their originals. How would this post-conceptual site re-define the practice of Joachim Schmid?

It is not the practical and pragmatic limitations that are at stake here. Considering the massive output of Joachim Schmid – the sheer number of photographs that make up his collected works – it might indeed be physically impossible, at least for a mere mortal, to perform such a feat, regardless of any other complications. But the more interesting challenge emerging from this idea is the conceptual ground from which to consider such a(n) (im)possibility. What would make such a practice possible? How could it take place? Borges is rather brief and not of

much assistance regarding the methods of Menard. But in attempting to think through the task at hand, it appears that Schmid has already invented the relevant methodologies through which to trawl the landscape of contemporary and historical photographic production with such attentiveness, such care, meticulousness, precision, stamina, endurance and obsession, and then to order, sort, classify, map, organise, structure and compose it with the empathetic dedication characteristic of Schmid's work. To explore all the facets of contemporary visual culture. To roam the streets of European and non-European cities in search of the discarded photographs waiting for their angel. To scout the flea markets, the antique shops, the junk-yards, the forgotten archive. To ask the citizens of the world to relinquish their photo albums, their archives, their collections, their images, their treasures, for the sake of entering the vast taxonomical grid and edifice that is Schmid's oeuvre. Or, to put it more straightforwardly, Schmid has already demonstrated, possibly even invented, the methodology that makes a Menard possible. Whether Schmid has made use of this methodology to actually perform a Menard is another question.

This apparent methodological affiliation between the work of Schmid and Menard clarifies another relationship between the two artists. There are few other projects in the history of cultural production that as radically as these two reject the auteur principle, the authorial voice, the signature style, that so embody the death-of-the-author paradigm. Menard hands over all the power to Cervantes (or is it Borges?); Schmid lends his versatile perceptiveness to the collective consciousness of the community of photographs – and their makers. Others occupy their oeuvres. Acts of impersonation, transgression, ventriloquism; positions of anonymity, mimicry or mediation. All of which turn out to be more complicated than expected. Something leaks between the personal and the collective, between the individual and the anonymous commune, something spills over from original to copy, and the copy begins to live its own life. Borges notes this when, in choosing between Cervantes and Menard, he indicates a preference for Menard, arguing that '...The text of Cervantes and that of Menard are virtually identical, but the second is almost infinitely richer. As three hundred years have passed, charged with the most complex happenings – among them, to mention only one, that same *Don Quixote*.'

Now, the reader has almost certainly already intervened with the conclusions above and rightly claimed that the comparison between Menard and Schmid is off-balance as there is no original to Schmid's work. Indeed, there is no novel, be it visual or textual, such as *Don Quixote*, that Schmid imitates or re-writes; Schmid's re-photography is of another order than that of Menard's re-writing. Yet I would insist that we ask if there isn't, after all, an 'original' to the work of Schmid. And if that original is nothing less than that real and imaginary whole of the photographic medium itself – the sum of its possibilities, the extension, the outline and the actual contents of the photographic universe. This is the 'original' of the work of Joachim Schmid. In Vilém Flusser's terms, it is the entire and complete output of the programme producing technical images or photographs. This is what Schmid imitates, explores, structures and creates.

All those photographs out there in the world – homeless and parentless, deserted and uncared for, neglected and discarded, lost and forgotten, misunderstood and unattended, ridiculed and disused, unseen and disregarded – would be comforted to know that they have one guardian, one caretaker, one friend, one *curator*, and that is Joachim Schmid. The Schmid moratorium on photographic production was not an act against photography as such, or against any single photograph, but, on the contrary, an act of concern for all those existing photographs neglected in photography's call for membership to the art world's institutions, and in search of futures yet to come. Schmid's is a celebratory cry, a call for all living photographs to claim their Warholian rights and forget about the hierarchies of visual culture. Schmid neither elevates popular culture nor makes it banal (his art has little to do with kitsch or camp). The dedicated use of found photographs has nothing to do with turning them into art. Schmid does not attempt to attain a levelling of meaning or to describe the collapse of communication, so often heralded as a consequence of the exponential increase of imagery. On the contrary, we could see his work to be about the rediscovery of meaning. Underneath that pre-determined image-repertoire of the amateur photograph, which assures that repeated stereotypes and clichés are produced again and again, other narratives are uncovered – life stories we don't and will never know, but whose existence we can intuit in Schmid's work.

Returning from the dead, as it were, that diffuse and undifferentiated mass of photographs begins to talk, to speak, to assert its stories. The act of making photographs is equated with other aspects of human communication – talking, writing, speaking, making love, embracing, crying, photographing. The photograph never existed simply to record or document a given piece of reality. Its singular and infinitely repeated mission is to reach out, reach out for human contact in the face of the banal finality of death.

Joachim Schmid has ventured to preserve and manifest photography's popular culture, to retrieve the collective conscious – and unconscious – of that aspect of human culture known as photography. He has set out to produce an exhaustive and encyclopaedic mapping of that vast class of material objects known as photographs, especially focusing on the vernacular, mundane or supposedly trivial classes and genres within the visual culture of photography. At the same time, Schmid has explored and described the network of human processes involved with photographs: collecting and discarding, caring and not caring, remembering and forgetting, treasuring and disregarding. Of all his major works, *Archiv* is the most obviously taxonomic project, in fact Linnaean in its character, developing an inventive visual identification of the tropes, genres, themes and subjects we find in vernacular photography. However, acutely aware of the open-ended and rapidly changing nature of the photographic enterprise, Schmid understands that the science at hand is always open-ended, imprecise, and so chooses to shape his work in organic rather than analytic terms – discoveries rather than certainties, suggestions rather than conclusions. There are innumerable ways of organising the universe of photographs. *Archiv* suggests one. Other works, such as *Bilder von der Straße* are drawn more towards representing or narrating human activities with photographs – the phenomenon of loss or abandonment or even destruction. Why is a photograph thrown away or even torn to pieces?

Given the processes of classification, taxonomy, categorisation and ordering, it would appear that Schmid is concerned with the *studium* of photography, with the general and shared knowledge about the workings of photographs – their commonly held meanings, their shared impact within the boundaries of society, their general intentions, effects and uses. And with the broad map of photographic practices which Schmid actually

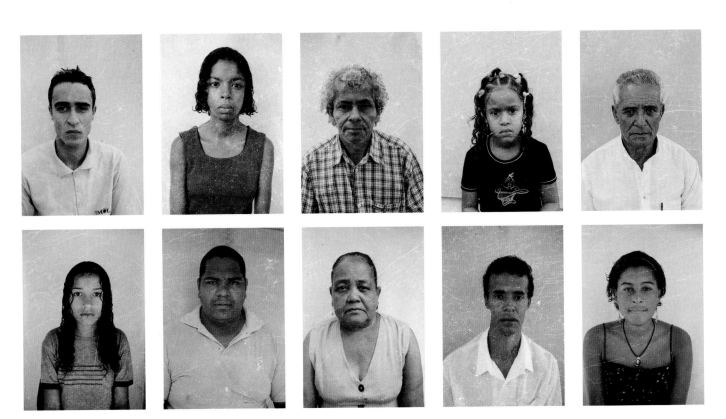

From: Belo Horizonte, Praça Rui Barbosa, 2002

supplies, it is certainly possible to extract such information from Schmid's works. However, handling such quantities of photographs with respect and care, Schmid's engagement with the photographic universe opens up another opposite trajectory concerning the specificity and individuality of photographic meaning. Take any photograph from *Bilder von der Straße*, the young woman lying down, eyes closed, arms stretched out over her head for example. Only two people on earth, perhaps only one, a handful at the very most, will know the original meaning of this photograph, will know its specific weight and place in a few people's lives. We may imagine one of these rare but privileged viewers walking into a Joachim Schmid exhibition and being struck directly in the solar-plexus by a particular photograph. For all other visitors, potential and real, only the impoverished generic and general meanings attached to this photograph would be available.

But Joachim Schmid's mappings of vernacular and commercial photography makes manifest and complicates the various strands of photographic communication even further. Not only are we able to experience, or comprehend, these two oppositional processes – the general or generic meanings and the particular or individual meanings. Schmid's installations also prepare the viewer for another adventure. Visit a Schmid exhibition or glance through a Schmid portfolio or walk through his archive. Draw on your interest in *studium*, in social and collective knowledge about photographs, knowing that it is unlikely that there will be a photograph in his collections related personally to you. No matter how you proceed, nothing can protect you. Suddenly a single photograph will transform itself. And it will be a photograph that you have no personal relation to or particular knowledge about. Unexpectedly and unpredictably it will grab you, attack you, knock you over (I have not yet recovered from the faces of *Belo Horizonte*). Any photograph, it turns out, has the power to wound its viewers, to numb them, to prick them, as Roland Barthes puts it – this photographic experience being so clearly analogous to the Barthesian *punctum*. Unfolding the richness of photographic communication, Schmid enables our encounter with these three poles of photographic meaning – the *studium*, the *punctum* and the personal life narrative. And we might even claim, if it is possible to do so without collapsing into bombastics, that Schmid has uncovered further proof of the simple theses that every photograph is a matter of life and

death, a property photographs possess not only because of their relationship to time, but also because of photography's positions in the world. It is the gentle ironies or tongue-in-cheek sarcasms, so central to Schmid's work, which renders this fact bearable.

Erste allgemeine Altfotosammlung

Jahr für Jahr werden rund um die Welt unvorstellbare Mengen von Fotografien produziert. Wir alle tragen fast täglich dazu bei, den heute bereits gigantischen Fotoberg zu vergrößern. Doch kaum jemand macht sich Gedanken über die Folgen dieses scheinbar harmlosen Vergnügens. Die in allen Fotografien enthaltenen Chemikalien stellen eine enorme Gefährdung unserer Gesundheit dar; darüber hinaus beeinträchtigt die zunehmende visuelle Umweltverschmutzung durch Fotografien unser Denkvermögen – von der sittlichen Gefährdung unserer Kinder ganz zu schweigen.

Am besten wäre es natürlich, auf das Fotografieren ganz zu verzichten. Da es sich jedoch in vielen Fällen nicht verhindern läßt, müssen die vorhandenen Fotografien nach Gebrauch fachgerecht entsorgt werden. Seit Jahrzehnten warnen Fachleute aus Ost und West vor den katastrophalen Folgen des Fotobooms, doch die Verantwortlichen aus Politik und Wirtschaft stellen sich taub. Bis heute werden in Privatwohnungen und Betrieben Milliarden von Altfotos unsachgemäß gelagert; die dringend notwendigen Recyclingeinrichtungen lassen auf sich warten.

Um in dieser scheinbar ausweglosen Situation ein deutliches Zeichen zu setzen, wurde das private Institut zur Wiederaufbereitung von Altfotos gegründet. Das Institut verfügt über alle notwendigen Einrichtungen, um Altfotos jeder Art professionell wiederaufzubereiten oder – in hoffnungslosen Fällen – umweltschonend zu entsorgen. Wir sammeln gebrauchte, abgelegte und aus der Mode gekommene Fotos in Schwarzweiß und Farbe, auch Sofortbilder, Automatenfotos, ganze Fotoalben, Kontaktabzüge, Probestreifen, Negative und Dias, auch beschädigte und zerschlissene Stücke in kleinen und großen Mengen.

Altfotos gehören nicht in den Hausmüll, sondern müssen gesondert entsorgt werden. Viele Fotografien können wiederaufbereitet und noch einmal einem nützlichen Zweck zugeführt werden.

Senden Sie deshalb – der Umwelt zuliebe – Ihre gebrauchten Fotos an das Institut zur Wiederaufbereitung von Altfotos
c/o Joachim Schmid, Englische Str. 29, 1000 Berlin 10.
Telefonische Auskünfte: 030 / 392 83 49

Die Teilnahme am Altfotorecycling
ist garantiert kostenlos!

Erste allgemeine
Altfotosammlung

First General Collection of Used Photographs

Year in and year out an unimaginable number of
photographs are produced worldwide. Virtually every
day each of us enlarges this gigantic mountain of
photographs, without giving the consequences a
second thought. But while photography seems a
harmless leisure pursuit, the chemicals contained
in all photographs pose enormous dangers to
our health. What's more, photographs in such
quantities increase visual pollution and undermine
our thinking power – to say nothing of the
moral dangers they pose for our children.

In these conditions it would be best if we
stopped making photographs altogether – but in
many cases this is hardly possible. Therefore, it is
essential to professionally dispose of all photographs
once they are no longer needed. Experts from
East and West have warned us for decades about
the impending, catastrophic consequences of the
photo boom, but their pleas have fallen on deaf
ears among those responsible in industry and
politics. Today billions of used photographs are
stored improperly in homes and businesses, waiting
for desperately needed recycling facilities.

The Institute for the Reprocessing of Used
Photographs, privately founded in 1990, offers
a clear path out of this seemingly inescapable
situation. The Institute maintains all facilities
necessary to professionally reprocess photos of
all kinds – or, in hopeless cases, dispose of them
ecologically. We collect used, abandoned and
unfashionable photographs in black and white or
colour, including instant photographs, photo booth
strips, entire photo albums, contact sheets, test
strips, negatives and slides, as well as damaged and
shredded items, in both small and large quantities.

Remember, used photographs do not belong in
the household garbage – they need special disposal.
Many photographs can serve a new and useful
purpose after reprocessing. For the sake of our
environment, send your used photographs to the
Institute for the Reprocessing of Used Photographs.

Participation in this recycling programme is
guaranteed free of charge!

In 1990, Schmid mailed a modest, four-paragraph flyer
to a small number of German editors, friends, journalists,
artists, and authorities including the Berlin *Tageszeitung*
newspaper and the *Spiegel* picture archive, announcing
the founding of the 'The Institute for the Reprocessing
of Used Photographs'. It was presented as an ecologically
sound answer to the 'enormous dangers' posed by the
chemicals contained in photographs and the 'visual
pollution' that 'undermines our thinking power':
'The Institute for the Processing of Used Photographs,
privately founded in 1990, offers a clear path out of
this seemingly inescapable situation. The Institute
maintains all the facilities necessary to professionally
reprocess photos of all kinds – or, in hopeless cases
dispose of them ecologically. We collect used, abandoned
and unfashionable photographs in black and white or in
colour, including instant photographs, photobooth strips,
entire photo albums, contact sheets, test strips, negatives
and slides, as well as damaged and shredded items, in
both small and large quantities.'

In a quirky, wry manner, the flavour of the original
German text echoes the earnest tone of ubiquitous, Green
Party era exhortations to engage in 'umweltfreundlich'
('environmentally friendly') initiatives, purchase 'green'
products, and participate in a mania for recyling that
gripped Germany in the last two decades of the twentieth
century. A close reading of the announcement triggered
some readers' suspicions that the Institute was either
an elaborate parody, a scam, or both – particularly the
phrase, 'Many old photographs can serve a new and
useful purpose after reprocessing.' Nevertheless, it was
reprinted by a number of ecologically conscious national
publications, and enough people took it seriously to
produce a flood of photographs arriving weekly in boxes
at Schmid's fifth floor, elevatorless Berlin apartment.

The success of *Erste allgemeine Altfotosammlung*
[First General Collection of Used Photographs] far exceeded
Schmid's highest hopes, and the mountain of images
it produced soon exceeded the storage capacity of his
spurious, in-house 'institute'. Photographs of all sizes and
sorts arrived, including cartons of old family photos and
entire commercial archives. Making good on his text,
Schmid proceeded to 'professionally reprocess' as many
of them as he could into new panels of *Archiv* and
other artworks.

In one case Schmid received the complete inventory of a Bavarian portrait studio. After a call in which he assured the studio assistant that, yes, the photographs would indeed be either 'recycled' or professionally 'reprocessed', the studio staff carefully cut all the negatives in half before mailing them. Schmid was initially disappointed that such a large quantity of high quality, second-rate journeyman studio work had been rendered useless to him. After rejecting several other alternatives, he arrived at the idea of joining two different negatives and printing them together. The resulting works, *Photogenetic Drafts*, now exist as pieces in their own right.

Schmid chronicled this entire saga in a sixty-four page, self-published book. Available only in the original German, *Erste allgemeine Altfotosammlung* tells the story of the Collection, recounting phone calls from potential donors and Schmid's fascinating, bizarre and Kafkaesque exchanges with bureaucrats from the Federal Office for the Environment (Umweltbundesamt), who were preparing to sue him for unauthorised use of the United Nations ecology symbol in his original announcement. An additional series of phone conversations, letters, and legal demands from the copyright enforcement agency documents Schmid's insistence that 'aesthetic recycling' by an artist could be treated as both a valid response to the overproduction of photographs and a protected form of free expression under the West German constitution.

Erste allgemeine Altfotosammlung functioned both as a conceptual 'social sculpture' recalling the work of Joseph Beuys (an artist who had long interested Schmid), and as a pragmatic, albeit hilarious, means of obtaining the raw photographic material for new art. It displays the artist's unconventional sense of humour in full force, including its acerbic edge, and highlights his sharp ear for linguistic nuance.

Commenting on the project in a 1998 interview with Val Williams, Schmid noted that it was meant as a 'joke for the photography world but turned into something different which I couldn't control anymore. It got incredible publicity and as a result people called me day and night for advice, then sent huge amounts of photographs for recycling and the federal authorities tried to sue me. So on the one hand I had to work as a therapist and on the other hand as my own lawyer. None of these reactions was foreseeable but I enjoyed them all.'[1]

John S Weber

1 'Very Miscellaneous', Joachim Schmid interviewed by Val Williams, *Insight*, February 1998, p9.

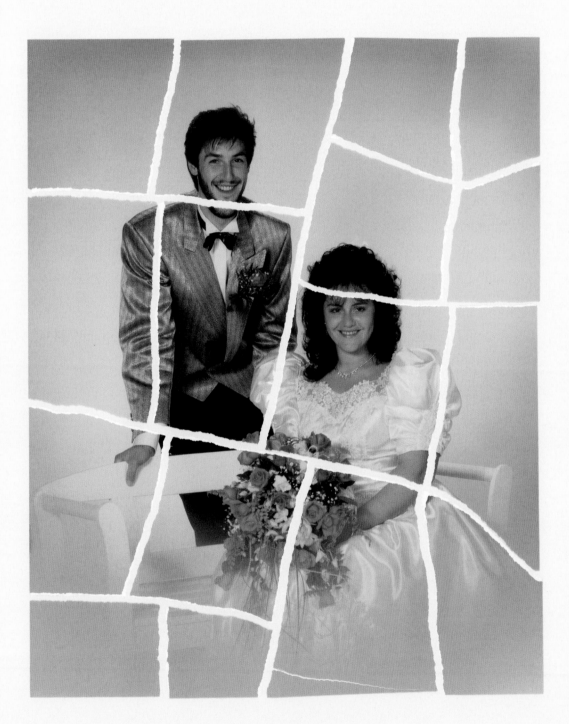

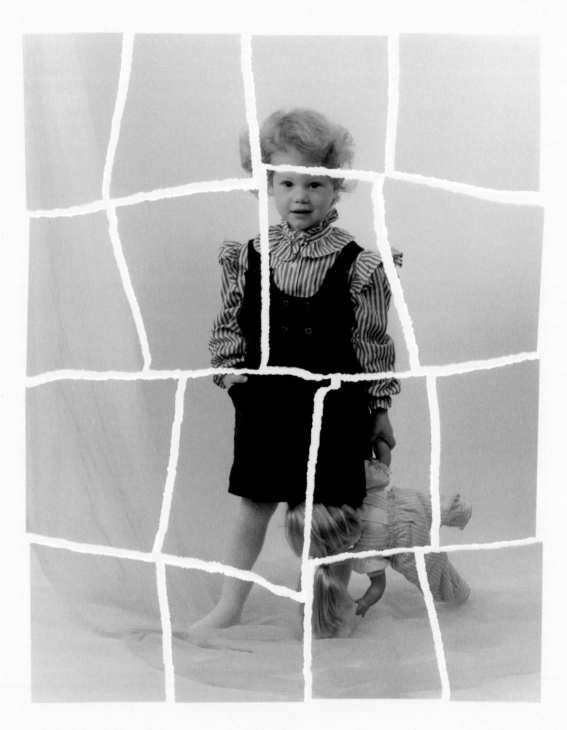

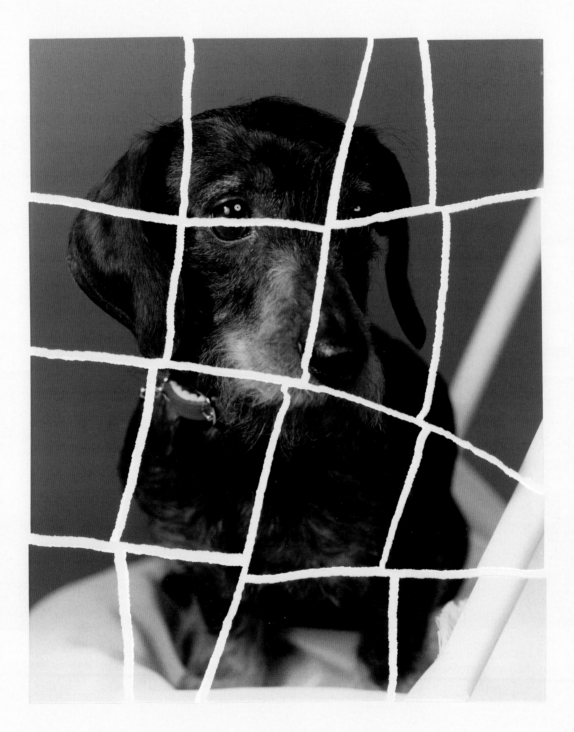

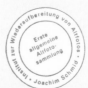

Photogenetic Drafts

Schmid's *Photogenetic Drafts* from 1991 was the most direct 'recyling project' to derive from *Erste allgemeine Altfotosammlung*. After receiving the entire archive of a commercial portrait studio in Bavaria, Schmid was initially dismayed to see that the photographer had cut all of his negatives in half to prevent their further use. Upon greater reflection, Schmid realised that the remarkably consistent point of view and camera position employed by the commercial photographer would allow him to combine two negatives into a single 'photogenetically spliced' image.

The resulting photo-collages highlight the predictability of the commercial studio headshot, deftly underscoring its conventionalised poses, expressions, and lighting. Neatly trimmed hair, carefully selected shirts, sweaters, and blouses, and self-conscious smiles all allude to the way that photography instructs its middle class subjects in proper self-presentation, thereby enforcing normative attitudes towards appearance.

Schmid's bizarre 'photogenetic' splices draw on remarkably bland source material to offer a twist that is both ironic and unsettling. Created at a time when there was much talk of DNA and gene splicing, his combinations of two distinct, but visually compatible headshots toy with questions of genetic inheritance, aging, gender identity, and personality. In *Photogenetic Draft #24* the face of a thoughtful young girl fuses with that of a woman whose eyes betray the lines of middle age to evoke the grown woman the little girl will become, and the child who will remain in that woman. The result is an initially humourous, yet strangely tender, gently affecting rumination on aging. Other combinations, such as *Photogenetic Draft #15,* join men and women in ways that seemingly depict an internal conviction that the man on the outside is, or wants to be, a woman on the inside, or vice versa.

In composing the photographic mutations that make up the series, Schmid began with nearly two hundred contact sheet splices. He selected the final thirty-two *Photogenetic Drafts* to avoid obvious monstrosities and misfits, seeking combinations that are neither cruel nor shallowly comical. The resulting set functions both as a single project, and as distinct, individual images.

Like all of Schmid's work, the *Photogenetic Drafts* both reveals and interrogates the nature of photographic practice in daily life, literally dissecting the work of everyday portrait photographers and their middle class, first world clients. At the same time, a close look at the individual images quickly leads to speculations about the people in them. Why, these images ask, is memory so important to us, and so linked to seeing and self-image? Why do we seek to capture and freeze in time the faces of our children, our parents, our lovers, and ourselves? Is what we look like who we really are, and if not, who else might we be?

John S Weber

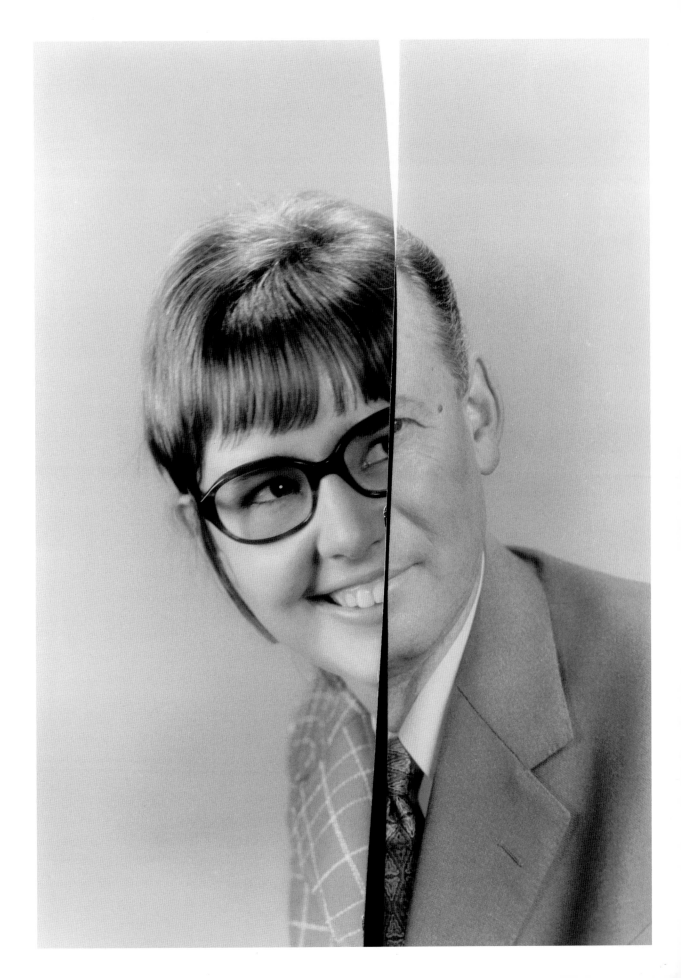

p116: Photogenetic Draft #7, 1991
p117: Photogenetic Draft #8, 1991

Photogenetic Draft #10, 1991

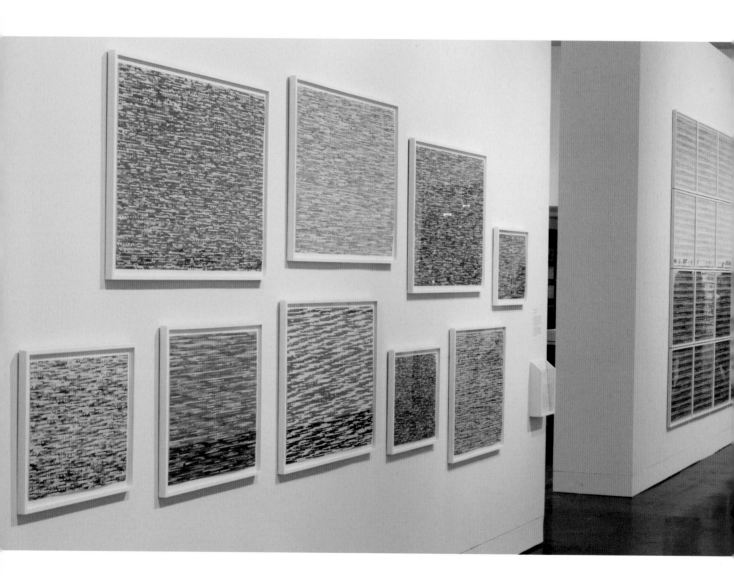

Statics

The abstract panels of the *Statics* series appear outwardly unlike anything else Joachim Schmid has done. They display shredded photographs and photographic imagery from vernacular sources and mass market catalogues, sorted according to genre and origin. To make them Schmid used an office shredding machine to slice apart many small pictures of the same image type, then carefully pasted the resulting strips together to create one larger visual field. The resulting pieces register generic aspects of tonality, colour, and grey-scale values that reflect the original content in a generalized but revealing manner.

As with the *Photogenetic Drafts*, Schmid's initial motivation for the *Statics* series derived from the mountain of photographs produced by his invented 'Institute for the Reprocessing of Used Photographs.' Confronted with far too much material to absorb in his *Archiv* and unable to find other, more specific uses for the boxes of photographs cluttering his Berlin studio, he needed a way to recycle large quantities of pictures easily and generically. The *Statics* were a logical solution.

All of the *Statics* panels display a horizontally linear, visually enervated, tonally chaotic, 'white noise' surface that initially masks the specific visual qualities of each piece. In fact, the differences are both striking and revealing. For example, the rich black-and-white tonality and even distribution of grey-scale values in *Statics (fine art photography postcards)*, 1999, is worlds away from the purple-orange-yellow palette and headline-heavy content of *Statics (magazine supplements)*, 2001. And while the dominant fleshtones of *Statics (lingerie catalogue 2)* of 2000 might be merely an intentional result of Schmid's image selection, or even a coincidence, it isn't likely. Nor is the contrast between the fleshy strata

of the women's catalogue and the black-and-white, business suit style of *Statics (men's fashion catalogue)*, 1999. Rather, mass market photography's starkly conventionalised nature is revealed in the *Statics* to encompass even the most nuanced, yet routine choices of colour, information density, and visual rhythm – choices that remain visible even when the images themselves are put into a blender and fragmented beyond recognition.

The photographer-critic Joan Fontcuberta has pointed to the sense of visual pollution and excess that Schmid's *Statics* allude to, registering the presence of too many garbage images and too much junk information in the world today.[1] The result is a blur, a photographic signal-to-noise ratio that numbs vision and dumbs down perception in ways that the *Statics* make tangible.

The largest piece in the series, *Statics (Marlboro billboard)*, is an oversized, sixteen-panel haze of yellow, white, black and red, produced for the 2003 Foto Biënnale in Rotterdam. Among other things, Schmid views it as a response to Richard Prince's rephotographed *Marlboro Men*. Like the other *Statics*, it is meticulously crafted, aesthetically exquisite, and yet experientially frustrating. The eye wanders restlessly, seeking a focal point, a pattern, and a way to fix the vibrating field before it. The act of looking, here, confronts too much photographic information to grasp, yet not enough to satisfy – much like the larger photographic universe Schmid is sampling. One might propose this as photography's paradigm, and also its paradox: there are too many pictures to look at, and yet we always want more.

John S Weber

1 Joan Fontcuberta, *Blink. 100 Photographers, 010 curators, 010 writers*, Phaidon Press, 2002, p321.

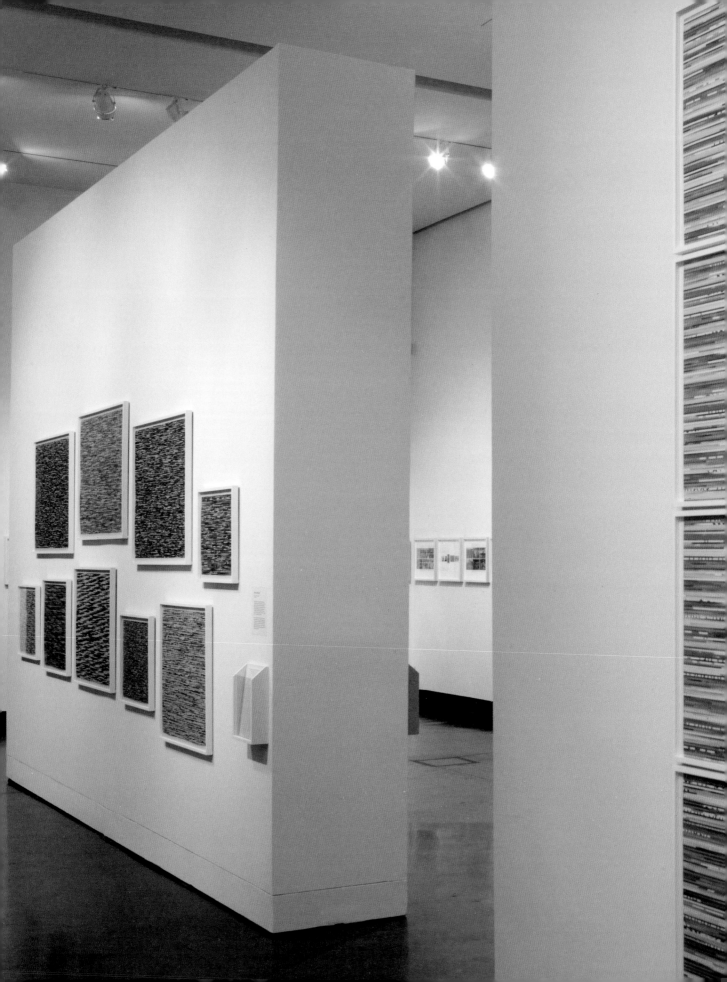

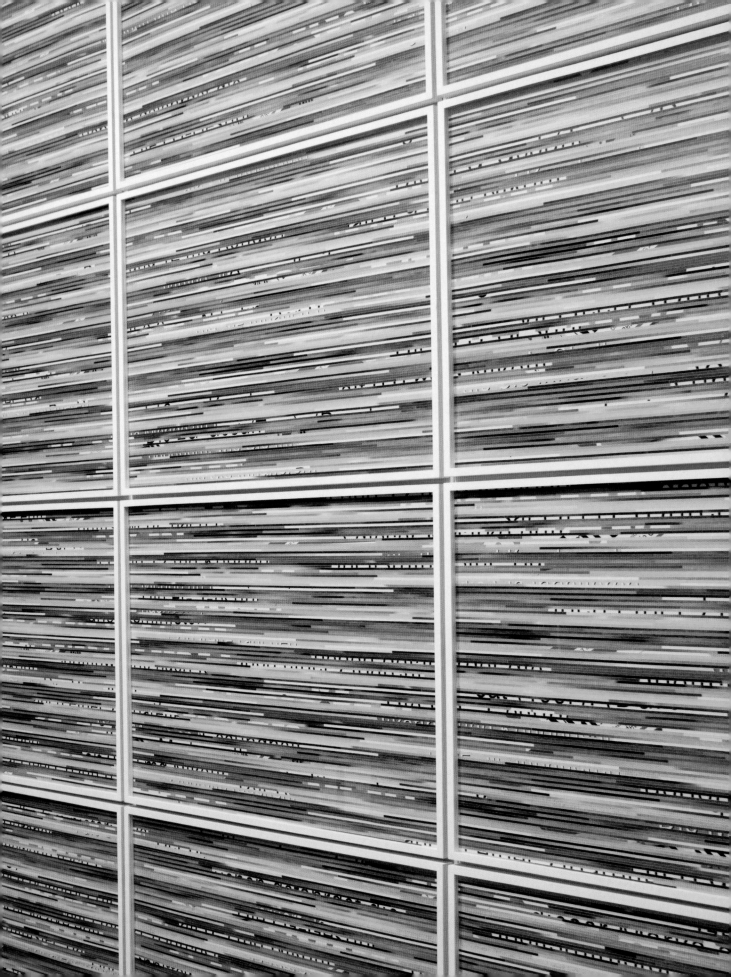

p142|143: Statics (Marlboro billboard), 2002,
235 x 315cm (detail), courtesy Nederlands Fotomuseum

p144|145: Installation view, Tang Museum,
Skidmore College, 2007

Statics (women's fashion catalogue), 1999, 60 x 80cm

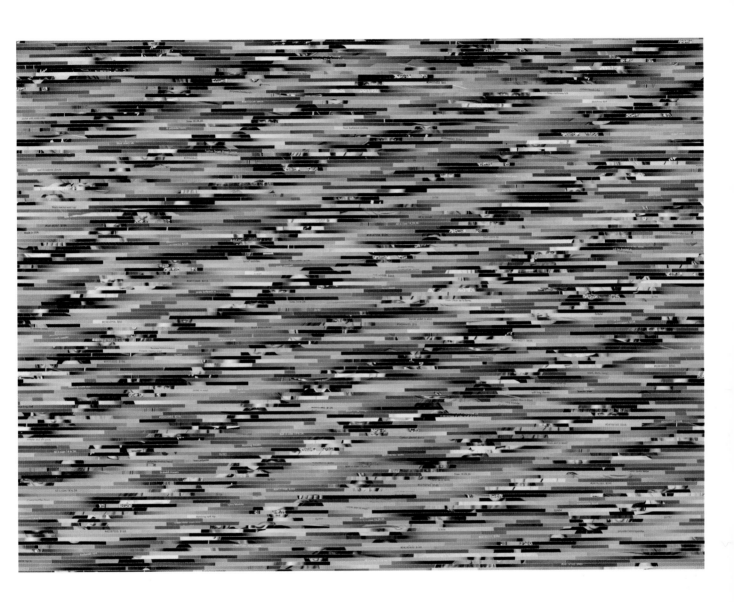

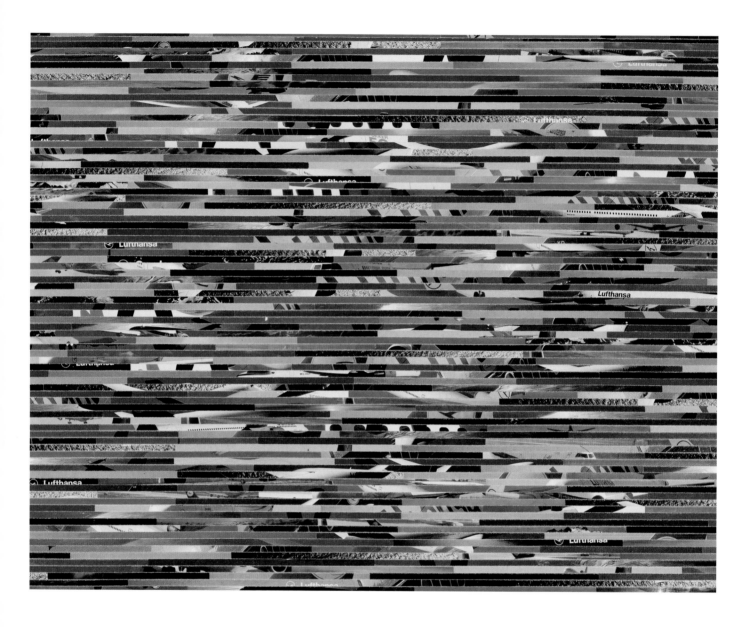

The Predator of Images

Joan Fontcuberta

The first work of Joachim Schmid's that I happened to chance upon was the series *Meisterwerke der Fotokunst. Die Sammlung Fricke und Schmid* [Masterpieces of Photography. The Fricke and Schmid Collection], produced jointly with Adib Fricke.[1] It surprised me, because I had thought that Schmid's main interests were theory and criticism; it was no accident that at that time he was busy editing and publishing *Fotokritik* (1982-87), a modest and entirely self-run magazine whose photocopied issues featured scholarly essays, and most of our encounters had been in the context of conferences and symposiums. However, with this visual project Schmid took his place in that club of artist-theorists that flourished with the advent of postmodernity in the late 70s and early 80s: if artistic creation was conceived as a statement, then theoretical writing could be approached as artwork. The philosophy of the club was marked by a post-structuralist reflection on conceptual art that was minimalist in its forms, with an underlying will to *détournement* that was grounded above all in mass culture and the history of art. Up until that time, photography in Berlin had looked to be more or less dominated by another Schmidt, Michael, whom the combination of (a) a greater orthographic orthodoxy in his surname and (b) the fact of having been a policeman before becoming a photographer, seemed to identify with a strict adherence to law and order. And, in effect, from the *Werkstatt für Fotografie* in Berlin-Kreuzberg, Michael Schmidt preached the hard line of authoritarian documentarism that was then the canonical mainstream. In contrast, the other Schmid, the upstart, the heterodox, was indelicately engaged in irreverently probing the open sores in the body of the great dominant discourses of visual culture. One was the sheriff of the photographic scene, and the other an outlaw in the style of Robin Hood.

In the *Meisterwerke der Fotokunst* there are already intimations of some of the characteristic Schmid approaches that culminate in the *Statics* project. In the last third of the twentieth century photography underwent a cyclical shift, and one of the most visible aspects of that change is its full-scale incorporation into the art market. To ensure the success of this process of artistic institutionalisation, the strategies of proactive marketing had to bring a series of factors into play, one of these being the setting of academic historiographical standards with which to categorise notions such as 'author', 'style',

1 Schmid subsequently published a second series on his own entitled *Masterpieces of Photography. The Source Collection* (original title in English).

'school', 'work' and so on; in other words, to provide a history of photography as art that would facilitate the creation of appropriate hierarchies. The year 1989 marked a milestone in this endeavour with the pomp and circumstance of commemorating the 150th anniversary of the official birth of photography: a number of major museums staged monumental exhibitions celebrating that hegemonic historiography. At the same time there was a determined advocacy of a series of values related to the photograph as merchandise and as collector's item: the fetishism of the signature, the notion of the original, the limited edition, the technical qualities inherent in the singularity of the photographic print, the *mise en valeur* with the appropriate presentation: in other words, the recovery of the aura. The combined operation of these two theoretical mechanisms served to discriminate and isolate, among the huge outpouring of photographic images, those that are worthless and those deemed worthy of selection and conservation in the archives and – why not? – the honours of the museum.

It is a well known fact that Fricke and Schmid confined themselves to visiting junk shops, flea markets and second-hand booksellers, rummaging through box after box of anonymous amateur snapshots, and selecting those images in which they seemed to discern an affinity with the unmistakable work of some great master (Atget, Sander, Adams, Moholy-Nagy, Magritte, Hockney, etc): that is to say, images that possessed both formal and thematic iconic features readily apparent in the stylistic repertoire of those 'masters'. Extracted from the impersonal, supersaturated magma of banal images, the chosen photographs were converted into the kind of unexpected treasures that every collector dreams of stumbling across some day. Duly adorned with all the exhibitive resources of the museological apparatus (mounted on passe-partout, framed, accompanied by captions attributing false dates of execution and titles reminiscent of pictures by the photographers whose authorship was to be implied), the pseudo masterworks were destined to provoke the greatest misapprehension among the public.

With this action Schmid and his collaborator Fricke levelled a merciless critique at the notion of genius, of style, of canon... extending even to the whole notion of the masterwork. Suddenly tremors were felt to shake the very foundations of the idea of the masterwork: it was no longer the product of creative genius but a simple

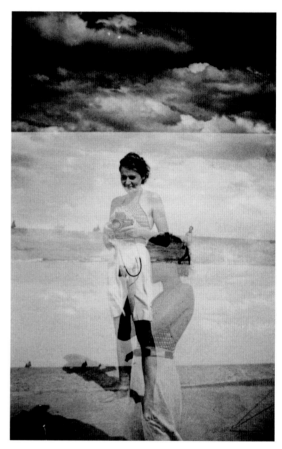

René Magritte, Georgette, 1937
From: Meisterwerke der Fotokunst.
Die Sammlung Fricke und Schmid
[Masterpieces of Photography.
The Fricke and Schmid Collection],
1989.

statistical result. The photos rescued by Schmid cannot be considered *fake* masterworks in the strict sense; they are really *alternative* masterworks, because we have been left with no clear criteria as to what the authorial value of a picture should be based on. Among the millions of images generated at random it will always be possible to identify a Moholy-Nagy or a Robert Frank. The merit that we assign to a picture no longer resides in the process of its making but in the act of recognising it; a new use will derive from that recognition. What is important in the photographs does not lie in the excellence of the process by which they were obtained, or in the ability of the eye, but in the function that we oblige them to perform, in their *management*, in the mission we assign them. In the adoption of that Duchampian gesture the creative act no longer consists in the application of a primal gaze but in a superposed gaze.

On an ideological plane, Schmid warns us of the excessive proliferation of images that contaminate our visual culture and proposes to launch us on an ecological campaign. As standard-bearer of a new Recyclationist International he seems to hurl to the four winds his proclamation: 'Photographers of the world, unite and halt your useless, excessive production, recycle what already exists!' Obviously this is a rhetorical demand that pertains to the order of the symbolic. Schmid knows very well that even though there is nothing left to photograph, our post-industrial society has a voracity for visual information that is never sated. And it is there that the spirit of visual ecology that informs his work acts: it is all about recovering things from the scrap heap; creation has been displaced onto the act of pointing out and using the exquisite refuse. It is not only in Duchamp and the Dadaists that the root of this approach lies; there is also, of course, the conceptual art of the late 60s, and the *arte povera* that imposed its sway above all after Documenta V in Kassel in 1972, and then branched into different schools of appropriation and recycling.

And there is another theoretical point to be deduced from Schmid's discourse on the dual nature of the photograph as information and as object. Every photographic print is at one and the same time a graphic representation that depends on perceptual and cultural factors, and a material support with its characteristics as an object (three-dimensionality, texture, weight, etc). The evolution of photography can also be read as an ongoing

process of slimming down the support: from the daguerreotype on a thick copper plate presented in a wooden case to the immateriality of the digital image. But as Schmid makes clear in his own words, this dichotomy brings us to some of the central postulates of postmodernist doctrine: 'On the one hand, every single photograph represents or depicts a fragment of reality, while on the other, that same photograph is a part of reality, both as a physical object and as an image/symbol. It's much more interesting to use these existing images and work with them than making new photographs, because existing photographs not only represent parts of our realities, they are realities. Today's reality is the reality of images.'[2] In effect, images of the world have given way to the world of images; our experience is no longer dependent on actual reality but on the images of that reality that have been disseminated. And just as in the Platonic cave, the world of things seems abstract and remote, because all we have direct access to are its shadows.

In the series *Statics* (1995-2003), Schmid further radicalised his practice, adopting an aggressive process that entailed the actual destruction of the 'original' images. For this project, Schmid made use of all the unserviceable images left over from other series, squeezing the last drops out of his reserves of photographic garbage: anonymous photos, prints, postcards, advertising brochures and so on. The challenge once again was to obtain something new by reutilising graphic trash that had already been rejected in various previous phases. It was a question, then, of giving a last chance to repeatedly discarded graphic material. In this instance Schmid was to use a device also employed in industrial recycling: a paper shredder. Slicing up original photographic material is something that tends to make conservators and archivists very nervous, concerned as they usually are with saving and restoring all kinds of documents. The fact is that there is a tendency to sacralize history and its vestiges; memory should not be a cemetery, and the museum should not function as a mausoleum that serves only to glorify the past. On the contrary, history must be able to regenerate the present and provide an incentive for the future, and thus the first critical duty of those who manage history is precisely to offset that 'excess of history' that Nietzsche diagnosed as a dead weight on life. So what is to be done with the historical heritage? How can we prevent institutionalised history from restricting our experience of the present and the future? How do we

2 'Very Miscellaneous', Joachim Schmid interviewed by Val Williams, *Insight*, February 1998, p8.

balance a respect for the ancient with the freedom of action needed to solve our problems now?

This is an especially relevant issue in architecture, which calls for controversial decisions about the rehabilitation of buildings and sections of urban fabric. It is difficult, for example, for politicians and archaeologists to resist the cult of the ruin. In the visual arts the iconoclastic spirit of the avant-gardes has frequently resulted in the damaging – 'purifying' – of previous art. We might think here of the famous moustache that Duchamp painted over the Gioconda's smile, although the truly revolutionary gesture would have been to add the silly moustache to the original in the Louvre rather than a mere reproduction. In this respect Robert Rauschenberg took this Duchampian principle to its ultimate consequences when in 1953 he physically erased a drawing by Willem de Kooning and justified it on the grounds that destruction can also be an act of love. More recently, Jake and Dinos Chapman decided to 'improve' Goya's engravings; poor Goya, who during his lifetime had to put up with deafness and suffer the Inquisition, has posthumously had to endure the Chapman brothers replace the faces of the victims depicted in *The Disasters of War* with the faces of dolls and clowns, a transgression that was no doubt aimed more at provoking a media scandal than theoretical reflection. And in the realm of photography examples can also be provided, such as the American Gary Brotmeyer and the Spanish Carmen Calvo. Brotmeyer collects old *cartes de visite*, which he cheerfully proceeds to paint on, scratch and cover with collages of different materials in the exercise of a delirious fantasy; the playful tone of the results deflates the hieratic solemnity of these portraits taken from family albums. If Brotmeyer offers tiny one-off originals, Calvo produces giant canvases to which she attaches photos, objects and all kinds of materials related to memory. The process of creation thus involves a form of therapy that purges recollections; the sepia prints embedded in and fused with the canvas serve to exorcise the marks of time. Another photographer, Tom Drahos, burnt copies of photographs in order to re-photograph their charred remains and ashes.

In short, with varying fortunes, a certain current of artists has sought to strip history and its mementos of their authoritative discourse. The belief in a unitary history directed towards an end has been replaced by the multiplication of a great number of value systems and by new criteria of legitimation. Two quotations, one from a philosopher and one from an artist, perfectly bracket the registers of this debate. As George Santayana wrote: 'Progress, far from consisting in change, depends on retentiveness. When change is absolute there remains no being to improve and no direction is set for possible improvement: and when experience is not retained, as among savages, infancy is perpetual. Those who cannot remember the past are condemned to repeat it. In the first stage of life the mind is frivolous and easily distracted, it misses progress by failing in consecutiveness and persistence. This is the condition of children and barbarians, in which instinct has learned nothing from experience.'[3] The kernel of that quote ('Those who cannot remember the past are condemned to repeat it'), voiced by politicians and true patriots, has resounded *ad nauseam* in the ears of my generation. However, Louise Bourgeois responded concisely to this warning: '...Se libérer du passé, c'est commencer à vivre' [to free oneself of the past is to start to live].[4]

Obviously Schmid subscribes to the posture of his sculptress colleague. In *Statics* a small office shredder was the instrument used to destroy and recycle. The images that fed it were the remnants of previous projects: given that Schmid's work required huge quantities of photos, in 1990 he created the imaginary 'Institut zur Wiederaufbereitung von Altfotos' [The Institute for the Reprocessing of Used Photographs]. He took out advertising space to explain that the accumulation of old photos could be prejudicial to health and went on to offer to take them away. A lot of people took him seriously and sent him whole archives of useless photographs, which he then applied to subsequent ideas, organising this raw material on the basis of random thematic families (postcards of Paris, press photos, exhibition invitations, baseball cards, tourist brochures, etc.). The arbitrariness of these typologies allowed him to ironise classification criteria and the numbering system in the thematic cataloguing of the archives, not unlike the semiotic deliria of John Wilkins described by Borges.[5] Once the photos had been 'ordered' into groups they were ready to pass through the sharp blades of the shredder. When the photographs had been reduced to the familiar narrow strips of paper, far from throwing them away, Schmid arranged them with saint-like patience in a collage of parallel lines, but in completely random order.

3 George Santayana, *The Life of Reason*, Volume 1, 1905.

4 Louise Bourgeois, *Les lieux de la mémoire. Œuvres choisies 1946-1995*, Musée d'Art Contemporain de Montreal, 1996.

5 Borges quotes from a spurious Chinese encyclopaedia entitled *Celestial Empire of Benevolent Knowledge*. 'In its remote pages it is written that the animals are divided into: (a) belonging to the Emperor, (b) embalmed, (c) tame, (d) sucking pigs, (e) sirens, (f) fabulous, (g) stray dogs, (h) included in the present classification, (i) frenzied, (j) innumerable, (k) drawn with a very fine camelhair brush, (l) et cetera, (m) having just broken the water pitcher, (n) that from a long way off look like flies.' (Jorge Luis Borges, 'The Analytical Language of John Wilkins', *Other Inquisitions*, 1952).

Statics (pinup postcards), 1998, 50 x 60cm

Statics (baseball cards 2),
1996, 40 x 50cm

Statics can thus be read as a commentary on the archive in terms of loss: it confronts us with a dialectic between documentation and experimentation, or between memory and forgetting. It also confronts us with the institutional mandates that correspond to the archive and the museum. The museum, the place for which the works of *Statics* are ideally destined, thus becomes – in contrast with the archive, the place that they come from – an arena for speculative discursivity. The postmodernist sensibility speaks of the ruins of the museum, but in fact what happens is that the museum surrenders to forgetting in a hybridisation of genres that perverts the whole notion of the document. The terms are inverted: the documentary photograph invades the space of art to the extent that the photograph as illustration occupies the pages of the information media.

If we look, on the other hand, at the process of its configuration, we find that *Statics* falls into two semantically charged phases: deconstruction and reconstruction, or fragmentation and synthesis. The deconstruction of that meaningless trash information is reconstructed in signifying structures by means of a 'white noise' effect. In cybernetics, white noise is defined as a random signal that has a constant value at each frequency (its potential spectral density is flat); in other words, a uniform distribution of energy across the spectrum of frequencies, so that the transmission signal is decorrelated (its values at any two moments are not related). The works in *Statics* clearly resemble the hypnotic effect of the lines on a television screen when it loses the broadcast signal: the signal is there but the coding is faulty. Similarly, in Schmid's *Statics* all of the information contained in the original archive persists. In the strict sense, what has happened is not a destruction but a transformation: a reordering (a disordering) of the formal attributes that renders the content inaccessible. The information is physically there, but unintelligible to us; it has been encoded in such a way that we are no longer able to decipher it. As a metaphor of what happens in so many archives, the documents no longer shed light but confuse us. Or, as Borges was so fond of saying, it is as if the map has suddenly turned into a labyrinth: it no longer guides us but makes us lose our way.

At the same time, *Statics* parodies the concept of fragmentation that has been so crucial to the whole process of constituting the modern sensibility. The

fragmentation syndrome began to emerge with Romanticism and its confrontation with the will to harmonic integration of the Classical world: for thinkers like Schiller and Schlegel the breaking of the unity of man is largely due to the specialisation of knowledge and the division of labour. With the abandoning of the old established hierarchies and homogeneous tendencies, the creative mechanisms started to deploy themselves in diversity. The Romantic artists fashioned themselves in a plurality of styles and a historicist eclecticism that progressively intensified, in due course bringing us to the historic avant-gardes. The image as a repository of experience of the world and a material part of this world had already been subject to fracturing interventions that explored the relationship of the part with the whole: Impressionists, Futurists, Cubists and others replicated the fragmentation of reality in the fragmentation of the representation. And from the 1990s up to the present time, fragmentation has given rise to a variety of formal creations, not only in the field of art but also in architecture and design.

Alberto Manguel, a close associate of Borges, delights in dismembering and recombination in his novel *The Over Discriminating Lover* (2006). With a humour as caustic as Schmid's, the narrative tells the story of the photographer Anatole Vasanpeine, born in Poitiers at the end of the nineteenth century. His life, divided between his job as a watchman in a public bath house and his devotion to the art of light, is marked by a secret gift that will determine his tragic end: a fragmenting scopophilic impulse, a quality of the poetic eye that impels the possessor to see reality piecemeal rather than whole. Vasanpeine photographs blindly through the cracks in the walls to capture portions of the naked anatomy of the bathers, both men and women. When he develops the plates, the photographer obtains for his voyeuristic delectation a washed-out, abstract mosaic. The selective portioning up of the body leads to a form of undefined fetishism, an excitement that feeds on the dissolution of identifiable forms. This impulse, compulsively cultivated, induces the protagonist to believe, as Schmid also seems to be telling us, that there is more truth in the image of reality, which is perennially enduring, than in the vision of the real, which is fleeting. In the dismemberings and recombinations of *Statics* may lie an understanding that our vision is always fragmentary, a part of a structure that we can only with difficulty see in its entirety. Schmid shows that he has sufficient lucidity to interrogate, by means of the chaotic gibberish of fragmented lines, the jigsaw puzzle of the real. He shows, in short, that without that fragmented structure no image is truly possible.

Translated from the Spanish by Graham Thomson.

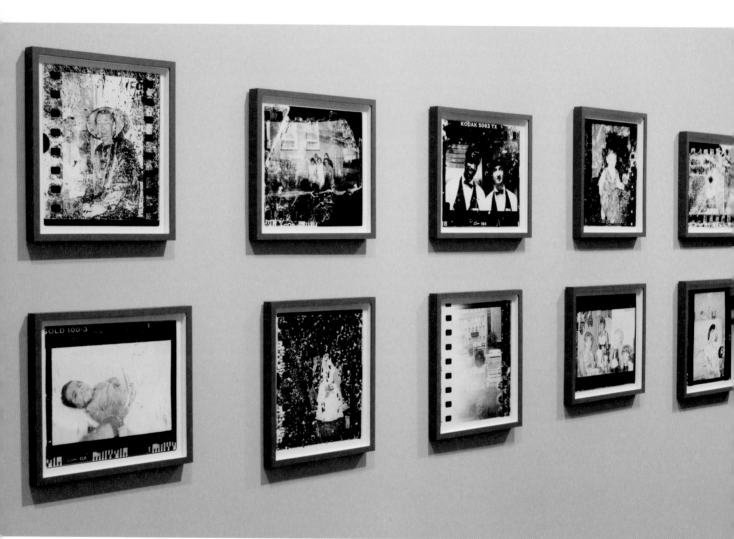

Arcana

The signature photograph in the *Arcana* series features the image of a woman, her face backlit and barely visible, photographed on a Berlin apartment balcony. Full-figured with shoulder length hair, she poses directly in the lower centre of the image. Her elbows rest lightly on the balcony railing. Notably, her head is framed perfectly by a Fix Foto lab storefront across the street directly behind her, lending the picture a curious meta-photographic air. Schmid found the negative himself in 1986 on the sidewalk outside the lab, where it was almost surely developed and then either lost or thrown away. A series of sprocket abrasions suggest the film was improperly loaded at one point, and the left side of the image itself is slightly washed out, as if the camera was opened accidentally. As a whole, the image exudes a slightly mysterious grittiness.

Like *Berlin, April 1986*, the other examples of *Arcana* were printed from found negatives. In this respect the series bears a superficial resemblance to *Bilder von der Straße*. But Schmid selected the images in *Arcana* 'for impact',[1] picking out found negatives that displayed resonant photographic scenes. The act of printing was also an act of discovery, revealing secrets hidden in the negative. He printed the pictures in a scale similar to that of traditional black and white art photographs, but with the unexposed film edges and sprocket holes showing, signalling that there is something different about this rather off-kilter collection of pictures.

All of the images feature human subjects, sometimes in groups and sometimes alone. At times they look like negatives thrown out because of double exposures and other poor camera techniques, such as *Lisbon, March 1993*. Other images, like *Paris, August 1995*, are flawed only by a few scratches, and appear otherwise fine. Why they were thrown away or lost is anybody's guess.

Madrid, February 1992 shows a small child on a bed. What seems to be a woman's hand reaches into the picture, perhaps holding the hand of the child. Is the child lost, sick, dying? It's impossible to say. For Schmid, that's the point: there's no inside story; no one knows more about these images than anyone else. Schmid's interest in these photographs lies in his complete inability to answer the questions they provoke, to provide the real story behind any of them. The photos themselves demand that viewers conjure up stories to account for them, but all the artist can tell us is where and when he found them, and why he picked them, not what they really describe.

Since at least the 1970s, the uncertainty, instability, and fluidity of meaning in photographs detached from known histories and anchoring captions has been a recurring topic in photographic criticism.[2] But whether this condition is perceived as a problem or an opportunity depends on the use to which the images are put.

Arcana functions as a visual treatise describing the mute nature of the photographic image by deprivileging the role of the artist in assigning and asserting meaning. Like it or not, the audience is left to its own devices here, as in so much of Joachim Schmid's other work. Some viewers may perceive this as a kind of abandonment. Others, and Schmid himself, will surely understand it as a form of liberation.

John S Weber

1 Joachim Schmid, in conversation with the author, 24-26 May 2006.

2 This topic appears, for example, in Susan Sontag's *On Photography*, and in the work of artist-critics such as Allan Sekula, Martha Rosler, Victor Burgin and others.

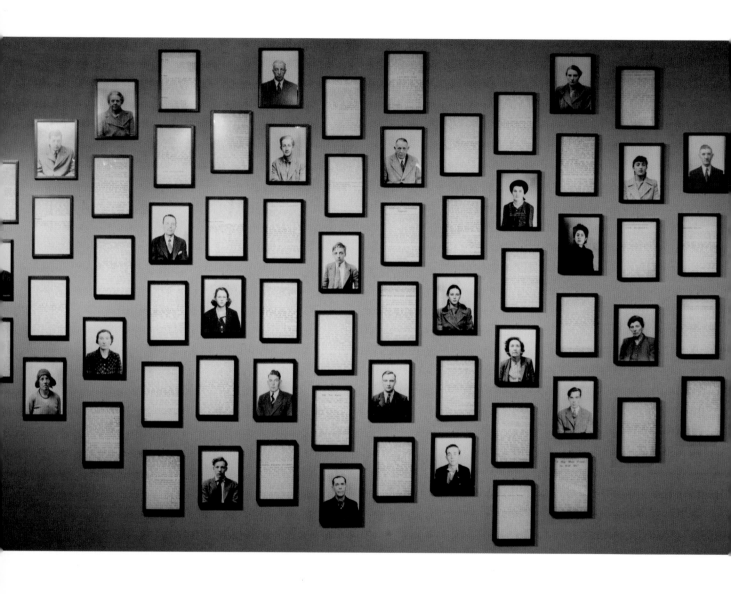

Very Miscellaneous

Very Miscellaneous was commissioned in 1996 by Val Williams for Photoworks and produced in collaboration with the George Garland Collection at the West Sussex Records Office in England. The project brought Schmid to West Sussex to work with the archive of 70,000 negatives and photographic prints left by George Garland, a hardworking commercial photographer who lived and worked in Petworth for his entire career. Schmid's curious title derives from Garland's legacy itself. Most of the negatives Garland printed were sorted by the photographer according to subject matter and combined in albums. In the private collection of a local historian, Schmid found additional Garland material, including boxes labelled 'Miscellaneous', and 'Very Miscellaneous'. The latter contained photos of a swan that had flown into an electric pole, a car accident, and a few nudes. Enchanted by the title, Schmid appropriated *Very Miscellaneous* for the name of his project as a whole.

Combing through contact prints of the Garland Collection, Schmid was most intrigued by a series of simple, straightforward portraits of village residents. They gaze directly at the photographer's lens with calm, largely uninflected expressions. The sitters have all 'dressed up' for the photographer, but the clothes aren't fancy and a slightly rumpled look prevails. An older gent is still wearing his heavy wool overcoat on top of a jacket, white shirt and polka dotted tie, suggesting poor heating, a cold studio, or a quick sitting. A man with no visible upper lip and sensitive eyes has two v-neck sweaters on under his jacket. The background is neutral and the lighting mostly flat. The images look like they might have been made to be cropped as ID photographs, but it is unclear whether they were ever printed and used. Overall, the images convey an outward sense of plainspoken humanity that reveals, in the end, very little about the inner lives or outward successes, failures, false starts and small triumphs of the people themselves.

Surveying the rest of the archive, Schmid found little he could work with but was impressed by how thoroughly Garland had chronicled the most mundane aspects of village life, and how often. 'Not only did he photograph the potato harvest, he photographed it *every single year*, and the same was true of the fox hunt and hay making and seemingly everything else that happened there'.[1] Eventually, Schmid was driven to ask himself what Garland might not have photographed. To answer the question, he surveyed the local newspaper of Garland's era.

The final form of *Very Miscellaneous* brings together twenty-six of Garland's Petworth portraits with forty-four photographs of contemporaneous newspaper articles, shot in shallow focus by Schmid himself. Conceived as a single installation and also as an artist's book project, the piece weaves together the two kinds of photographs to create a 'fabric of memory'.[2] Text is present, but as a photographic image that underlines its fragmentary, edited character. Bits of news stories imply lives and fates sketched in with the barest of facts. 'In March, 1949, said Miss Carter, "he rejoined the Army. I continued to go out with him when he was on leave and in September, 1951, we became engaged. I did not know that he was already married and on 29 October, 1951, we went through a ceremony of marriage at Hor–...."' The rest, literally, is a blur.

Stories of accidents, deaths, and quotidian disasters alternate with less ominous incidents, yet the overall tenor of *Very Miscellaneous* is somber and restrained. Words and faces conjure up a ghostly image of rural English life, forming a spectral gallery of anonymous faces and unfinished narratives. The collective portrait Schmid creates is all the more tantalising in its refusal to pretend to know, or reveal, more than it can. In emphasising the fragmentary, incomplete nature of all photographic information, *Very Miscellaneous* points out, again, that the reticence of the found photograph is precisely the source of its allure.

John S Weber

1 Joachim Schmid, in conversation with the author, 24–26 May 2006.

2 ibid.

...

1 11,000 and where the true Ger-
t and atmosphere prevailed. The man
his concern "showered him with
ty de luxe" and conducted him thr
xtensive workshops.

they met in the office the telep
rang and in lifting the receiver
ger began his conversation with '
.'" There was nothing loud or ex
the tone of his voice and the sp
rds learned that the term w
greeting taking the place of '
...

LAST ROLL CALL

As each coffin was borne from its
he boy's name was read out an
mourners followed behind. Whe
ast coffin had passed through the
ay, members of all the Civil I
nits, including those of neighbour
ges marched to the graveside.

"He loves the Army, and he signed on for five years," said Mrs. Leggatt. "The trouble with my family is they are all Army mad."

She said: "My Dad was an ex-Guardsman. My brother Maurice Matthews was on the Reserve in the Coldstream Guards. He rose to the rank of Captain, was de-mobbed at the end of the war, re-joined the Army later and is now Sergt. Major. He is in the Royal Sussex.

"Did Not Know"

Miss Carter told the court that she met Page in Bognor in November, 1948. He was then a civilian.

"In March, 1949, said Miss Carter, "he rejoined the army. I continued to go out with him when he was on leave and in September, 1951, we became engaged. I did not know that he was already married, and on October 29, 1951, we went through a ceremony of marriage at Horsham Register Office."

Miss Carter said that after the ceremony she and Page went

Mr. B. G. Langford, representing the parents, thanked Mrs. Kent for her work during the past nine years.

"You have done your best for each individual pupil," he said, "and by your hard work brought the school to its present standard, which is as high as, or higher than any school in West Sussex."

Mrs. R. Fentiman, a past pupil, made the presentation of the dinner-service.

er (counter, and Dr. N. A. time
ent.)

he interesting feature of the meeting
tanding of issues received from the
ttention met. This was done by
se.

WHY HAS TENSION ARISEN?

his letter Baron Von Lersner w
y did we understand each other so
year, and why has such a tension a
then?

think the reason for this is tha
ent nations never get a clear id
other on account of newspapers
cal speeches. Only when they h
nal contact with each other do th
they are really like. And one
closer face to face as in fighti
ghts and liberty of one's country
newspapers with false reports sta
on and one feels when the other
attitude. If it is face and face at
confidence

Joachim Schmid's
Very Miscellaneous

Val Williams

In 1996, Joachim Schmid was invited to produce new work for the *Country Life* project, organised by Photoworks and curated by Val Williams. The *Country Life* commissions were centred around the archive of the Petworth photographer George Garland, who, from the 1920s to the 1960s had chronicled the lives, faces and activities of people living in and around this small country town in the heart of the West Sussex countryside.

In his photographic practice, George Garland took advantage of the growing interest in country life expressed by both national and regional newspapers. With the growth of suburbs and the increasing concentration of labour into urban centres, rural life became ever more exoticised. Garland's primary source of income came, not from the procession of portrait sitters who visited his wooden studio in Petworth, but rather from the specialised agricultural press (*Farmer and Stockbreeder* magazine was one valued client) and, more interestingly, from the national and regional press. In *Proud Petworth and Beyond* (1981), Peter Jerrome writes:

'Many of the national newspapers ran a weekly farm column and for these Garland would submit topical pictures which would frequently find their way into print. Sussex local newspapers, more numerous then than now, would also use this type of picture and paid the princely sum of five shillings for the privilege. The national dailies would pay 17/6d but if, as was usually the case, the pictures had been placed through an agency Garland would receive only half of this sum. What he could not do with agricultural pictures was to sell them locally; the farm workers portrayed either did not want them or could not afford them and local people would not pay for shots of sights they could see for themselves in any field at any season. There was always then a 'speculative' element in his work. Sometimes the Daily Mail, Daily Express or New Chronicle would ring down for a particular illustration to service some copy that they had and Garland would either find something on file or go out and capture an appropriate shot.'[1]

The Garland archive is a substantial one, held at the West Sussex Records Office in Chichester and at Petworth House. Garland was a well-known photographic figure in West Sussex, whose work had been published both in books and in postcards, driven by the interest of local historian Peter Jerrome and the Petworth Local History Society.

1 Peter Jerrome and Jonathan Newdick, *Proud Petworth and Beyond*, The Window Press, 1981.

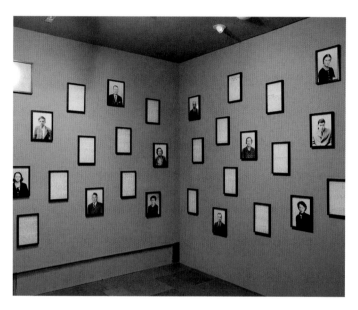

For the local community, Garland's photographs have proved to be a uniquely valuable source of information about Petworth's past – they give important clues to the history of this small settlement, dominated by an elegant country mansion and in thrall to the notion of aristocracy. Garland's photographs purported, in their careful documentation of country crafts and pursuits, to be a photographic representation of 'real life'. The Petworth Society, formed in 1974, has been a key player in the presentation of George Garland's work to a larger, if still primarily local, audience. Without the continuing use of Garland's photographs in its magazine, it is likely that his work, like that of so many other local photographers in the UK, would have become obscure.

In the March 1995 issue of The Petworth Society's magazine, Garland images used ranged from 'George Muncaster preparing for a one-man exhibition in London' (nd) to 'Winkle Ayling on Lurgashall Village Green' (c.1933) and 'Group at Duncton Village Hall' (c.1937) By assimilating Garland's work into the wider history of Petworth, the archive, though in its own way a fiction of rurality, became the visual representation of a complex history.

In the mid 1990s, the regional Arts Council invited Val Williams and Photoworks to work with the George Garland Collection. Though the content was at first sight somewhat predictable – a mass of photographs of rural life, many of which were clearly staged – groups of photographs began to emerge which were fresh and incisive. Chief among these were Garland's portraits, taken in a wooden studio in Petworth of people from the town and surrounding countryside. These portraits had rawness and a vivacity which overshadowed Garland's posed 'character' studies.

When Joachim Schmid, in 1996, was invited to respond to the Garland archive as one of the *Country Life* commissioned artists, he admitted to being bewildered by the collection: '...but at the same time, quite fascinated by the obsession with which he took them, over decades. However, I had no idea what to do with them. After looking at thousands of pictures of farmers, hunters, horses and sheep there was only one question: What did he not photograph? So I looked at the local and regional papers of the period to get another idea of the area. Then I began to construct a possible history of the region by using two descriptive systems. There are only a few overlaps, just a

few occasions when Garland and the editors of the papers were interested in the same subject. You can read the newspapers as a critique of the photographs and the photographs as a critique of the newspapers. I selected a series of simple, deadpan portraits from the Garland archive using these as anonymous substitutes for the local population and combined them with fragments of articles taken from the newspapers. There's no direct relationship between the texts and the portraits, but the events and ideas represented in these text extracts are particles of human lives, and they were probably of some importance at a certain moment in time to the people represented in the portraits. When presenting the texts, I was looking for a visual equivalent of fading memories, and finally found a way of photographing the texts which would convey this. Only a few lines are in focus, to give people an idea of what the original news story was, but then the letters fade away to blurred darkness.'[2]

In his first reading of the Garland archive, Schmid made an immediate connection with Garland as a purveyor of partly fictionalised 'documentary' photographs to the press. Dealing with these fictions, and also with the notion of history, Schmid explored the tantalising nature of photographs from the past, noted how they can become deceptive memories, part of a finely wrought picturing of the past. By using those portraits which had never become part of Garland's relationship with the press and by setting these against enigmatic fragments of texts, Schmid destabilises the archive, while at the same time making it coherent for a contemporary public. In much the same way, in The Petworth Society's magazine, Peter Jerrome had utilised Garland's photographs to present the Society's view of country life, acting as a visual codicil for a complex oral history, yet again presenting the past to a contemporary audience.

Very Miscellaneous is one in a sequence of commissioned works in the Country Life series which illustrated the complexity of working with local archives. Though the series as a whole received much critical interest, local reactions were muted. The George Garland Collection as perceived by Joachim Schmid and other commissioned artists and curators was not one of character and costume, but rather a series of enigmatic gazes which avoided the central theme of antiquity and craft, and concentrated on much bleaker visions of the shifting nature of history and memory.

For Schmid himself, Very Miscellaneous was a progression from 'previous projects which were more playful and ironic...Very Miscellaneous comes closer to 'serious work'. It's probably also to do with my nationality. I have never wanted to make a work about German history, something which seems to be inevitable for artists of my generation. They have to prove that they are good Germans who are terribly aware of history. But when I was in Petworth and Chichester I was once again confronted with a part of history (the boys' school in Petworth was destroyed by a German bomb in WWII and all of the pupils were killed) and thought about it quite a lot; maybe part of my thinking about this rather sinister history found its way into this work, though the work itself is certainly not my obligatory German history piece.'[3]

Very Miscellaneous is a haunting work of art, a collection of photographs of 'ordinary' people who become extraordinary when seen through the prism of Schmid's practice. Presented in simple black frames, hung at random and juxtaposed with fading and elusive texts, they become fabulous through their very normality.

2 Joachim Schmid in conversation with the author in Creative Camera, No.348, 1997.

3 'Very Miscellaneous', Joachim Schmid interviewed by the author, Insight February 1998, p7.

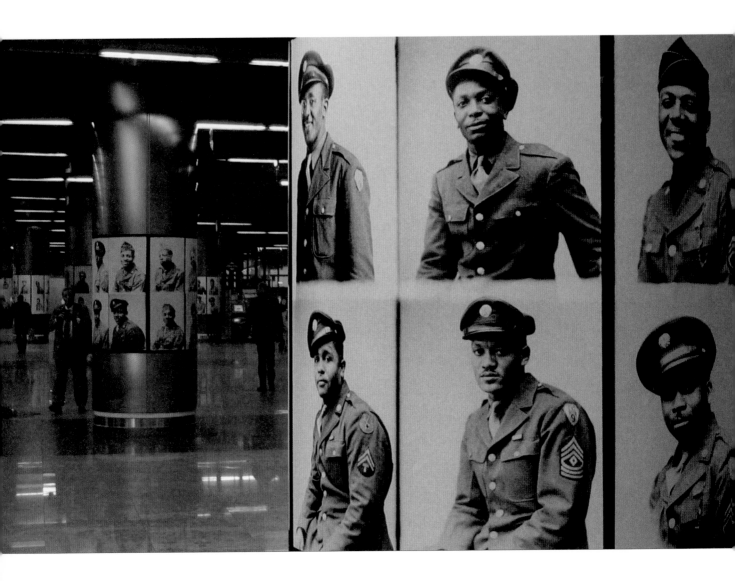

Decisive Portraits

While working with the George Garland Collection
in Chichester, West Sussex, England, in 1996, Schmid
encountered a surprising group of portraits showing
black American soldiers in dress uniforms. As part of the
Ninth Army Air Corps, they were stationed in the area
before debarking for the D-Day Invasion of occupied
France, and like nearly everything else in the town,
Garland photographed them. The portraits fascinated
Schmid on a number of levels, but he was unable to find
an immediate use for them in the book and exhibition
that initially emerged from the Garland commission.
Nevertheless, he made copy negatives of the eight
contact sheets in the hope that an appropriate venue
might present itself at a later date.

In 2004, Schmid was invited to propose a commissioned
public art project as the centrepiece of Photo España,
the national photography festival of Spain. Learning that
the opening of the festival would coincide with the 60th
anniversary of the 6 June, 1944 D-Day Invasion that
liberated Europe from Hitler, Schmid realised it could be
a moment to look again at the Garland photographs of
black American GIs. Discussions with the organisers of
Photo España led to a plan to install large-scale copies of
the images throughout Nuevos Ministerios, the immense
central station of the Madrid subway. The photographs
would be wrapped around support columns throughout the
three levels of the station and displayed, frieze-like, in the
main above-ground entrance. A short text explaining the
images and identifying the GI's themselves would be placed
in a central location, and fifty thousand inexpensively
produced booklets about the display would be distributed
for free to subway users during the opening of the festival.

As a postwar German planning a public art project for
Spain, where the pro-American government supporting
the Iraq invasion had just been voted out of office,

Schmid was hyperconscious of the stark contrasts
between the invasions of 1944 and 2003. The bombing
of the Spanish commuter rail and subway systems in the
spring of 2004 dramatically increased the timeliness of
Schmid's installation, without altering its fundamental
nature. Inserting images of American soldiers into this
context would make the piece a political intervention,
regardless of whether it took a position pro or con.

Titled *Retratos decisivos,* the Spanish installation of
Decisive Portraits silently asked viewers to compare two
projections of American military power overseas –
D-Day and Iraq – at a time when European sentiment had
turned increasingly against the United States. It implicitly
acknowledged a justified instance of American military
intervention, offering World War II as an unmistakeable
moral compass point. As Schmid stated unequivocally at
the press preview of Photo España, thanks to the sacrifice
of the soldiers Garland photographed in 1944, he did not
grow up a Nazi, and he was deeply grateful. What, then, to
make of the contrast between the war against fascism and
the unprovoked Iraq invasion undertaken on false pretences
by George W Bush and supported by Tony Blair? *Retratos
decisivos* posed the question, but did not offer an answer.

Schmid's intervention further complicated the
comparison between World War II and Iraq by utilising
Garland's moving images of black American soldiers as
the stand-ins for the US military. Mostly smiling, the
soldiers carry themselves with confidence and self-
possession before the camera. Yet their dignity projects
an image of racial equality that neither the military nor
American society had begun to attain at the time. Even
as they fought and died to free Europe from the racist
policies of Adolf Hitler, these soldiers still suffered from
racism at home and in the service. The stripes on their
shoulders testify that the military offered black Americans
a route to promotion and advancement, but in an
imperfect and still segregated system. It is telling that
there is not a single white face here.

The poignancy and beauty of these portraits is
inescapable, ineffable, and – perhaps primarily for American
viewers – profoundly painful. The distressed, time-ravaged
surfaces of some of the images seems strangely fitting. It
is as if the photographs themselves have died or suffered
grave illness. Despite their smiles, all is not well in the world
these men inhabit, nor can it be, given the course their lives
must take. Here is all the promise of American freedom and
democracy, and here also is its failure.

John S Weber

They came from the United States of America.

Evans, Garrett, Private in 9th Army Air Corps.
Coley, Chapman and a Master Sgt., 23rd Apr. 1944

They gathered in the south of England.

Pattiford – Goodlet, Johnson – Hovington
9th Army Air Corps, April 1944

They prepared for the day of decision.

Bradley – Bailey – Booth – Van Reed
9th U.S. Army Air Corps, April 1944

They made no decisions themselves.

Basden. Mils. Liggans U.S.A., May 1944

They imagined their lives after the battle.

Dulin. Slade. Johnson. Roebuck U.S. Army, May 1944

They had their portraits taken before leaving.

Andrews, Pte. Powell, Sgt. Montgomery, Sgt. Montague,
U.S. Air Force, May 1944

They left on the morning of June 6th.

Jones U.S.A., Nolan U.S.A., Scott U.S.A.,
Miles U.S.A., May 1944

Their portraits remained.

Bishop, Dailey, Bradley, Ferguson U.S. Army, 1944

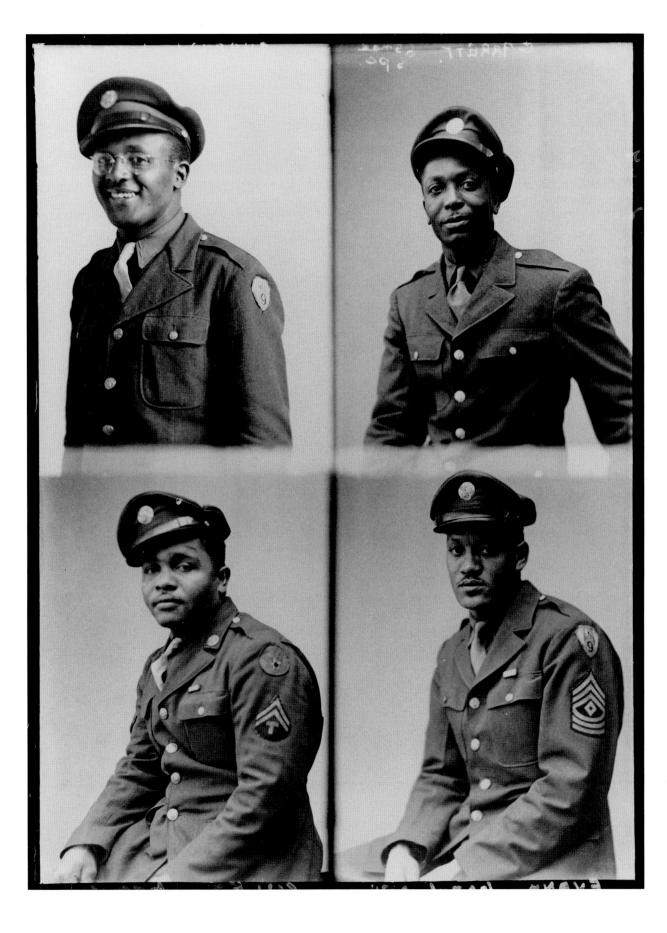

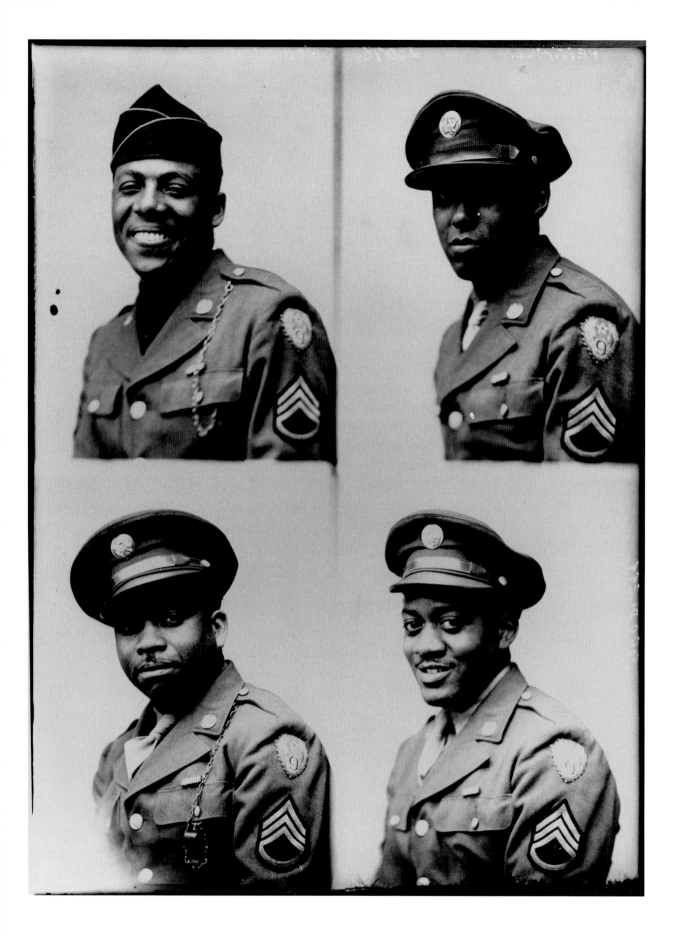

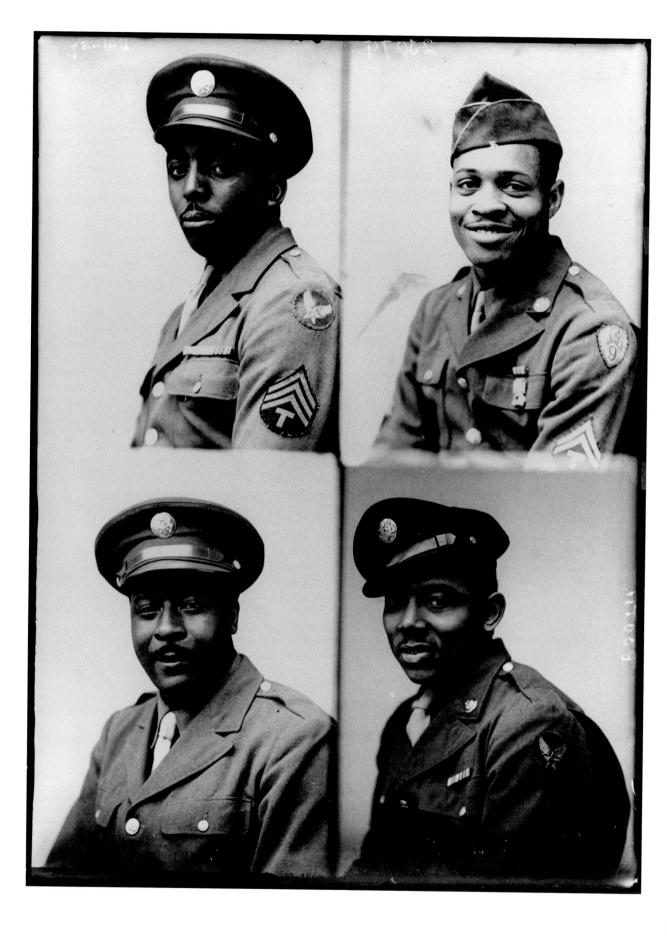

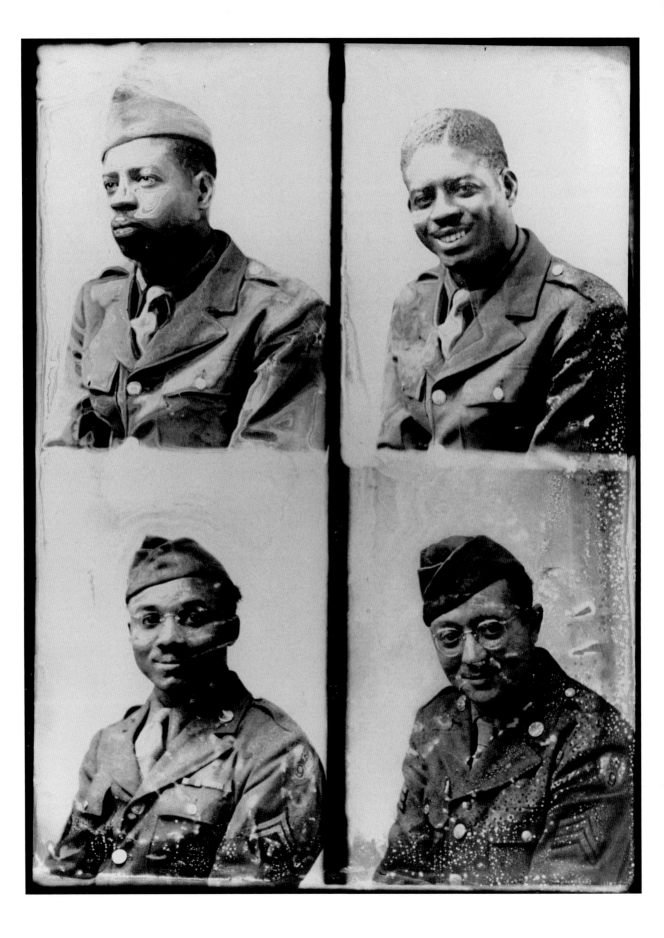

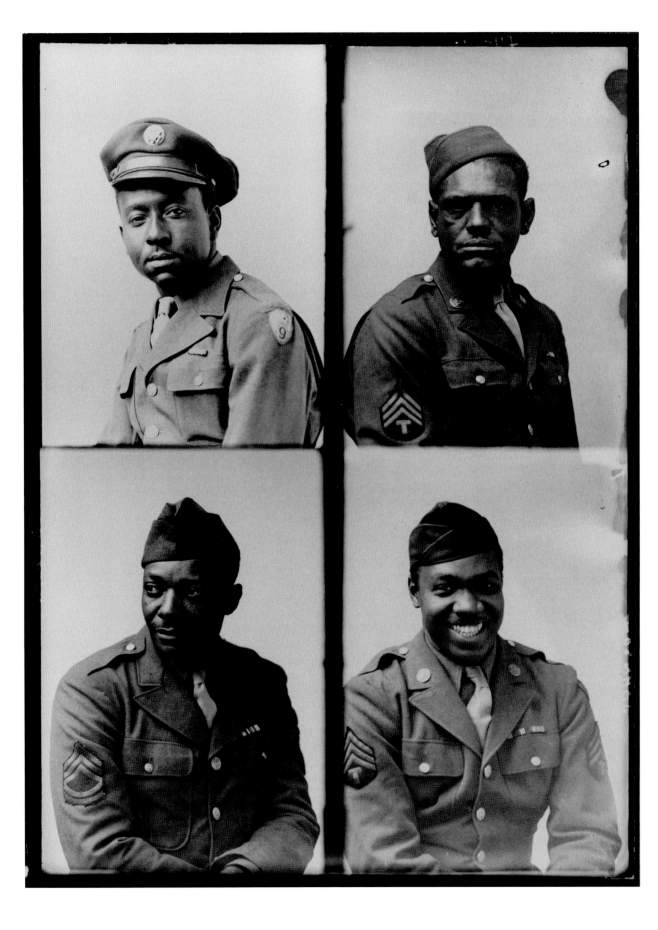

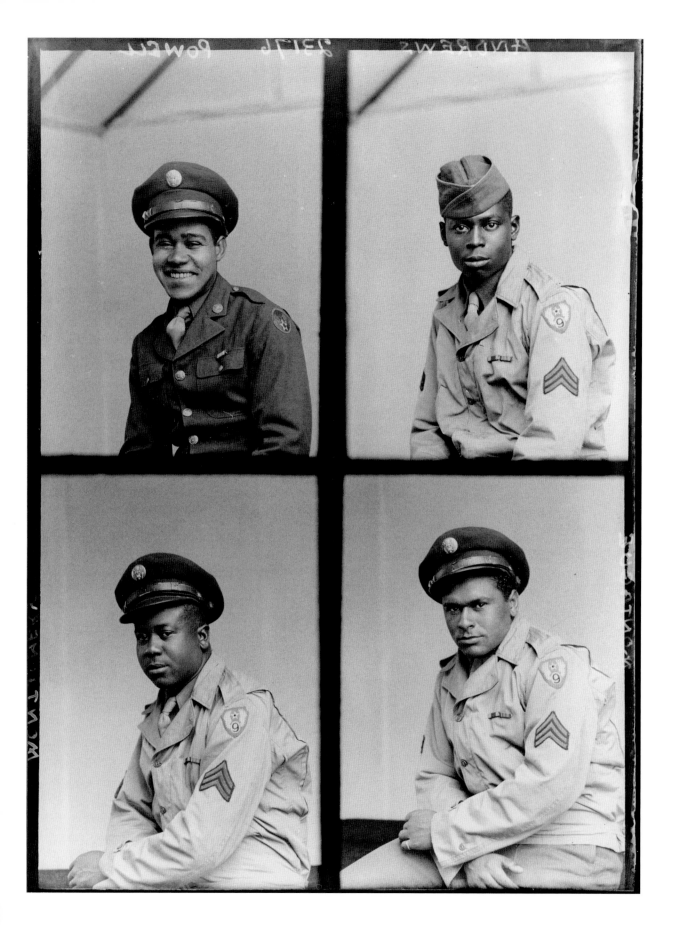

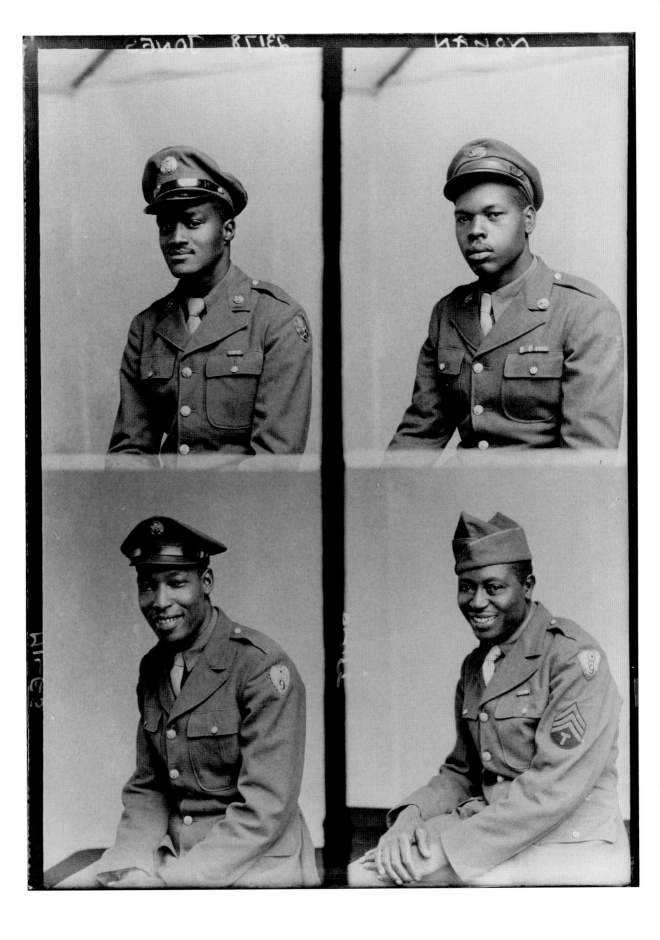

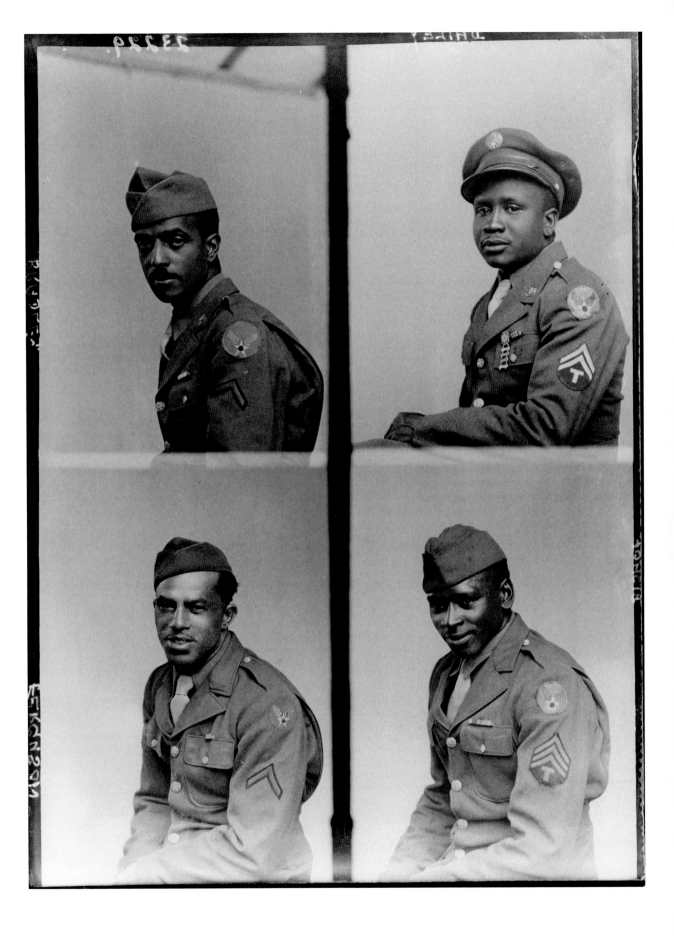

Sinterklaas ziet alles

Sinterklaas ziet alles includes one hundred and eighty inexpensive index cards printed on an offset press. The cards display a seemingly random collection of found images interspersed with short texts, shown in multiple copies on metal postcard racks in a large grid. When originally exhibited, individual cards could be taken by visitors in exchange for a small donation. The entire set was also for sale, unbound in a small box, for the cost of an average art catalogue.

Cheaply printed, the photographs are at times funny, frequently banal, and for the most part unremarkable except for the consistent, dismaying sense of déjà vu they provoke. We know these images, even the ones we can't possibly have seen before. Their order inside the grid is unpredictable, non-hierarchical and open-ended, in a word, anti-narrative. Order has not been imposed, merely avoided. In its absence, what's left is a series of precise visual and verbal notations that function like a tone poem sampled at a certain time and place in Western history.

Another way to read *Sinterklaas ziet alles* is to note that it contains too many narratives to control, functioning as an 'all over' composition sampling skeins of pre-existing cultural moments intertwined like the looping lines of a Jackson Pollock drip painting. The recently deceased Princess Diana makes a tragic star turn, interspersed with clipped images of a copy machine, an advertising shot of a young couple eating pizza, a shoe, and a beach scene. An ID photo of a young woman nestles with a surveillance camera freeze-frame of a guy carrying an unidentifiable white object in a dim parking garage, followed by a picture of five people wearing 3D computer glasses in a lab, and then a picture of an aeroplane in flight. Each image has a story, but the sum is never precisely greater than the parts.

Along with the pictures, *Sinterklaas ziet alles* contains short descriptions of things Schmid observed on his travels, mostly in 1997-1998, when the piece was commissioned by the Mondriaan Foundation of Amsterdam and the Nederlands Foto Instituut. The 1998 World Cup in France turns up regularly, as do observations about photography, images, and things that happened to Schmid on repeated visits to Holland. For example, it is clear why he'd be interested in the following scene, reported from Rotterdam, 5 August 1997: 'A rather nondescript young man stands next to the photo booth waiting for his pictures. The fan dries the photos, and the man looks at them with satisfaction. He leaves the train station and sits down on the bench of a streetcar stop. He takes scissors, glue, and a bodybuilding magazine from his briefcase and lays them next to him. Then he carefully cuts out the heads of his four portraits and glues them over the faces of the musclemen in his magazine. Finally he stows everything in his bag, crosses the street, and heads for a copy shop. He has coloured copies made of a few selected magazine pages, places the copies in a prepared envelope, and takes it to the next mail box.'

Two cards anthologize t-shirt texts seen by Schmid in Amsterdam and Rotterdam. Another recounts the late 1990s fad for Japanese 'tamagotchis', the electronic 'pets' that briefly captivated children around the world, only to vanish as quickly as they appeared. Another card details an attempt by British environmental activists to promote a 'No Shop' store, featuring empty shelves filled with 'no special offers', where the 'no sales assistants' bid farewell to customers with 'a cheerful "Thank you for not shopping at *No Shop*."'

The still-new world of the World Wide Web appears repeatedly in word and image, and Schmid has commented that the piece is 'like a blog before there were blogs.'[1] He has also noted that in structure it was meant to function 'like a book without a spine', presented as a 'non-structure' that 'points at things without claiming to analyze them.' More than anything, Schmid's non-structure echoes the nature of urban, pedestrian experience, functioning as a collage of random encounters linked by geography and time, yet otherwise unrelated.

The title, *Sinterklaas ziet alles,* is taken from a Dutch saying propagated in an advertising campaign in 1997 – 'Sinterklaas sees all'[2] – quoted by Schmid in the piece. What Sinterklaas mostly sees, according to Schmid, is a world in which products vie with celebrities and athletes for mass media attention, and, by implication, public mindshare. Sinterklaas ziet alles. 'It's probably not intentional,' Schmid says, 'but for me it sounds just as threatening as "Big brother is watching you."'[3]

John S Weber

1 All quotes and paraphrases taken from conversations between the author and Joachim Schmid, 24-26 May 2006.

2 In Dutch tradition, the feast day of Sinterklaas is celebrated on 5 December, the name day of Saint Nicolas. A forerunner of the American Santa Claus, Sinterklaas sees everything and knows whether children have been good or naughty.

3 From *Sinterklaas ziet alles*, on the card labelled *Rotterdam, 3 December 1997*.

Berlin, July 20, 1998

Balingen, July 18, 1997

A rather nondescript young man stands next to the photo booth waiting for his pictures. The fan dries the photos, and the man looks at them with satisfaction. He leaves the train station and sits down on the bench of a streetcar stop. He takes scissors, glue, and a body-building magazine from his briefcase and lays them next to him. Then he carefully cuts out the heads of his four portraits and glues them over the faces of the musclemen in his magazine. Finally he stows everything in his bag, crosses the street, and heads for a copy shop. He has colored copies made of a few selected magazine pages, places the copies in a prepared envelope, and takes it to the next mail box.

Rotterdam, August 5, 1997

Berlin, November 17, 1997

London, June 5, 1997

Berlin, August 3, 1998

An electronic "pet" invasion is currently the dominant topic of critical commentaries on our lives and times. New to Europe, these toys appear to be so widespread in Japan that serious defensive measures had to be taken. The newspapers reported today that Japanese schoolchildren were recently forbidden to bring their acoustically conspicuous and excessively attention getting Tamagotchis to class with them. Enforcing this ban was apparently none too easy. Now the schools are organizing psychological withdrawal counseling so that the children are looked after. The devices, which appear to die when not given regular attention, are cared for by technical personal during class time.

Balingen, June 19, 1997

Frankfurt, May 25, 1998

Rotterdam, July 31, 1997

Rotterdam, August 4, 1997

Rotterdam, August 7, 1997

A faithful reproduction of the torch held by the Statue of Liberty in New York has stood, barely noticed at the corner of the intersection for years now — donated by the *International Herald Tribune* to strengthen Franco-American friendship. It was in the tunnel under this sculpture that the Princess of Wales's car crashed. Now the flame serves as a bulletin board for the emotions. Admirers from all over the world have scotch taped letters, sayings, newspaper cuttings, and pictures to the torch — everything charmingly and carefully sealed in plastic as protection from the elements. Flowers rot away at the statue's base. In the midst of traffic noise a reverent silence reigns among the visitors. Every once in a while a commemorative photo is taken.

Paris, February 6, 1998

A woman around seventy, bent over with white hair and a cane; she is wearing a long pleated white skirt and walks over a subway ventilation shaft. Practically in unison three passersby call out, "Hello Marilyn!" Everyone laughs.

Berlin, July 17, 1997

Delft, September 9, 1997

Printing on T-shirts: Surf the net. Hard Rock Café Roma. Armani exchange. Puma. Dee Dee Ramone. I hate creeps like you! Bauhaus. Heineken. The front line. Summer. No mistakes, no progress. Wildwest coast style. Jurassic Park. Two minds without a single thought. Miss Pumpkin show 1997. Benetton. Survive your dive in deep waters. Nautika. Always for girls. That's a pretty good start. Army. Je t'aime. Australia. I killed my Tamagotchi. Sport. Fat Tuesday. Feyenoord zit in je bloed. Passion, love, sex, money. Save the planet. Drink in peace. Discover Holland by bike. Fanatic ultra style. Umbro. Ban waste trade. Face your fears, live your dreams. Giorgio. Pray for surf. Wrangler. Expression of the smashing colours. Timberland. Sun. G-Star raw denim. Wagada. Levi's since 1850. Hond in de goot! Good girls go to heaven, bad girls go everywhere. Piet Pendel. 49ers. Parmalat. Helly Hansen. The baseball hall of fame. Fruit of the loom. Bruce Lee. They call it paradise. Who's Mr. X? Mainstream. Motta. Open your mind so I can piss on your brain. It's me. Terror Traxx. Amsterdam — the place to be. Diesel. Two beer or not two beer, that's the question. Spice. The brand with the three stripes.

Amsterdam, September 3, 1997

Edam, September 12, 1997

I suspect that it all started with a coffee machine. Because the employees of some institute or another were too lazy to go into the kitchen a couple of times a day to see if the coffee was ready, they installed a surveillance camera that fed data directly into the internet. That way everyone can quickly check while calculating or writing if it's worth heading for the kitchen. Surprisingly, more and more people became interested in the status of the coffee, even people living at the other end of the world. The principle has established itself. We can now look in other people's aquariums, watch their flowers grow, accompany them on walks, and observe them get married. This summer a birth was broadcast for the first time via internet. The newest thing is *The Doll's House*, a camera-filled apartment shared by English girls with one hundred percent visibility. You can watch how the gals eat, pick their nose, or surf in the internet. Something really new is taking shape: a parallel universe.

London, September 24, 1998

Rotterdam, August 6, 1997

Amsterdam, September 13, 1997

The Long Walk

Frits Gierstberg

There is a long tradition in photography which is often overlooked, forgotten or ignored. It involves walking through the city, camera at the ready, in search of the picture in which everything comes together. It is a methodology central to that most important of genres, street photography. The photographer walks around and photographs those subjects that fall within a self-determined oeuvre and a fixed stylistic framework. It is not only reportage or documentary photographers working with a well-defined subject or theme who do this. There are a large number of photographers who choose their subjects intuitively, not knowing in advance what picture they are going to make until they see it – sometimes only moments before they click the shutter. The most famous and most influential example is the French photographer Cartier-Bresson, who in his wanderings was in constant pursuit of the 'decisive moment'. The other impressive example is the American Garry Winogrand who, contrary to Cartier-Bresson's highly selective way of choosing the best composed 'artistic' images, produced hundreds of thousands of street photographs in his famous 'anti-aesthetic' snapshot style. These traditions cohere with a certain mythic image of the street as the place where 'real life' in all its harshness and honesty can be found, and thus the place 'real' photographs come from. It is for this reason many photographers are regarded as 'knights of the street'.

Joachim Schmid enjoys playing games with these traditions and practices in photography. Walks through the city – initially through Berlin, where he lives, but later elsewhere as well – are the basis for many of his projects. He encounters his images by chance during these walks, be they long or short, with a destination in mind or apparently aimless. Schmid has made a number of projects involving images discovered while strolling through the city, which, back in his studio, he later incorporates into his work. Schmid doesn't make these images himself; he literally picks them up from the street, where they were lying, deliberately thrown away or inadvertently lost by their former owners. *Bilder von der Straße*, *Archiv*, *Arcana*, *Sinterklaas ziet alles*, *Photographic Garbage Survey Project* and *Belo Horizonte, Praça Rui Barbosa* are all comprised of numbers – sometimes large numbers – of photographs, negatives and (in the case of *Sinterklaas ziet alles*) texts found by chance. The work *Statics* can also be classed within this group, because it involves visual and textual

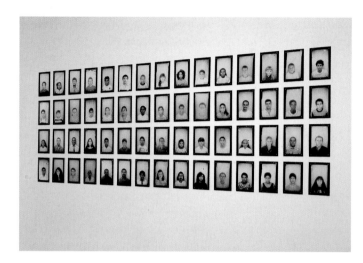

Belo Horizonte, Parque Municipal
(1993) at Neuer Berliner
Kunstverein, 1994
(photo: Jean Marc Tingaud)

materials (advertising folders, etc.) which Schmid found in his mailbox, having reached him by chance from the outside, via the street – one might say through a sort of counter-walk.

Walking as an 'artistic method' also recalls the work of a number of conceptual artists. Hamish Fulton and Richard Long made long hikes through the landscape, precisely documenting their journeys with photographs and text. In *This Way Brouwn*, the artist Stanley Brouwn allowed himself to be sent to certain places, directed by passers-by, documenting his route in drawn or photographed images and written text. Schmid's erratic walks through cities resemble On Kawara's peripatetic travels around the globe. In more than one way, Schmid's method of working can also be termed conceptual, though the systematic part of his process occurs after his walking, and the walk is not immediately evident in the final piece itself. (*Photographic Garbage Survey Project* is an exception to this.)

But of course there are also important differences between the ways these artists and photographers work. My concern here is to illustrate how, from a certain (deliberately chosen) distance, Schmid's work relates to the canon of photography and the visual arts. Over the course of his career Schmid has had some very critical remarks to make regarding the photographic and artistic canon, along with the mutual-admiration-society atmosphere that accompanies the small circles of the established high-brow art world. One could already hear this critical attitude in the 1980s in the periodical *Fotokritik* (1982-1987), which he founded. In his artistic work itself, however, Schmid never makes this critique explicit. His projects are in no sense a literal reaction to the canon or to established artistic practices. They are too far removed from them to function in this way. Yet this distance is not so great as to prevent a critique of the canon resonating through his projects in more subtle ways.

The strength of Joachim Schmid's work lies to a great extent in the simplicity of the idea or concept, the playful and sometimes entirely intuitive manner in which he approaches the development of this idea, and his own iron perseverance and system. He is always able to create an apparent paradox in his work – particularly in the projects mentioned above – in which, on the one hand chance is given full scope, while on the other there is an extremely precise and systematic process, encompassing

acts of ordering, numbering, conservation and other museological activities. This lends the work an enormous clarity and also a certain lightness, as if the material has hardly been touched by the artist, but is only momentarily arranged. As a result, the irony – that is to say, the critical charge – is strategically employed in the work, gaining enormous power.

This strategy makes Schmid – or Schmid's way of working – very difficult to define as an artist. Various critics have attempted to do so in the past, or at least made comparisons with Pop Art, for example, as well as with other professions or 'types', such as the flâneur, the collector, the archaeologist, the anthropologist, the sociologist and the archivist. Joachim Schmid is none of these, although the comparisons are not entirely unfounded. He does 'research', assemble collections and save cultural objects from oblivion. In addition, he produces works that offer insights into diverse social practices and phenomena in which photographs play a role. These can be all sorts of photographs and photographic representations: identity photos, family photos, photos in lonely-hearts advertisements, pictures of lost pets, postcards.

Schmid is not your average post-modern picture-jockey viewing all images as equal. For him, the found photographs are not only representations, but also objects. Photographs are artefacts, and bear the traces of their social functions and use. Personal photographs frequently end up on the street as the result of emotionally charged events, or their loss has an emotional effect on their owner. Evidence of use, of human contact, such as an obliterated face or a torn photo, can sometimes speak volumes. When, in *Photographic Garbage Survey Project*, Schmid constructed an extensive, systematic documentation including, among other things, precise information on the routes walked through Vigo, Paris, Berlin, São Paulo, Zurich, San Francisco and Rotterdam, and about the numbers of photographs found, this created a new perspective on the city as a social space. Schmid himself speaks of the project– not without humour – as an 'international compendium of pollution in modern cities'. A nod towards the photographic 'tradition of the street' is also clear, yet here the street is not the setting for the photographic aestheticisation of 'real life', but the material *Fundgrube* for it.

Schmid's description could equally apply to *Bilder von der Straße*, a project that he started in 1982. Photographs

that Schmid has literally picked up off the street in a period of twenty-five years are the basis for more than eight hundred and eighty panels, which now comprise the project. Among them are pictures from photo booths that the owners discarded as failures, photos apparently dropped by accident, photos bearing boot prints, torn photos with the pieces restored to their original configuration by Schmid. A striking characteristic of this project, which for that matter emerges even more clearly in the work *Archiv* (1986-1999), is that, in terms of their visual power, snapshots and amateur photographs can comfortably stand up to photographs from the canon, and that even 'lookalikes' of the most famous pictures from the history of photography surface with some regularity. Schmid is still adding images to this project, although as a result of digitisation its growth is gradually slowing.[1]

This last point is even more apparent in *Arcana* (1995), a project in many ways comparable with *Bilder von der Straße*. Here however the project revolves around negatives (or parts of them) found on the street, which Schmid himself has printed on his return home. In 'serious' photography, prints from someone else's negatives generally occur when a darkroom assistant prints according to the instructions of the 'master photographer'. With Schmid something else is happening: the artist brings an unknown private world to light through making the latent (or negative) image visible. In this act, which takes place within the intimate sphere of the darkroom, the old magic of photography, as an optical-chemical procedure that conjures up images, coincides with its classic function as a voyeuristic medium.

Though it concentrates on Brazil, *Belo Horizonte, Praça Rui Barbosa* (2002) is also related to *Arcana*. There Schmid discovered that the local portrait photographers in the city of Belo Horizonte, who generally work on the street, throw away the negatives immediately after they have sold the portrait print to the client. Here, Schmid printed the colour negatives again, but whereas *Arcana* shows a mixture of very diverse images, *Belo Horizonte* is characterised by a high degree of uniformity (it involves identity photos after all). The images from both projects are, unsurprisingly, damaged and scratched, because they have been exposed to wind and weather, not to mention the soles of countless shoes.

Sinterklaas ziet alles is a project Schmid realised in Rotterdam in 1998, as part of a programme of

1 Schmid's work is slowly taking on a new significance as a result of a number of developments in and around photography. Not only does his work cover the period in which analogue photography – if not photography as such – is disappearing, but in many Western cities the street has ceased to exist as public space.

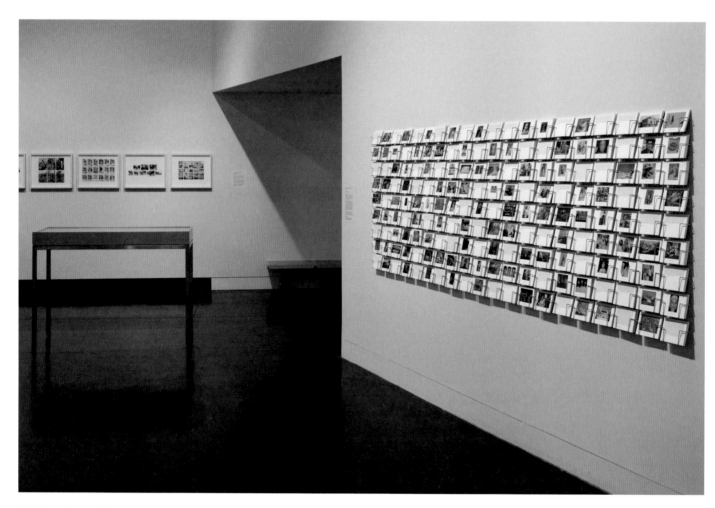

Sinterklaas ziet alles, 1998.
Installation view, Tang Museum,
Skidmore College, 2007.

international commissions surrounding documentary photography.[2] The title refers to the Dutch cultural phenomenon of Sinterklaas, who, little Dutch children are assured, sees everything they do throughout the year, and on his annual visit in December will reward or punish them accordingly. For this project Schmid again chose not to make images of his own, but to collect pictures that he encountered on the streets of Rotterdam, among other cities. Remarkably enough – and somewhat provocatively in this context – he also began to assemble random texts: both texts that he found on the street (notes, brochures, etc.) and his own notes of snatches of conversation that he overhead by chance in public and semi-public spaces (cafés, on the trams and subways, in stations). This introduced an artistic method relating to the tradition of journalism and photojournalism: writing up observations, reproducing fragments, or 'facts', from reality; apparently meaningful material that forms the raw ingredients for the research of the social scientist or journalist. The enormous numbers of separate images and texts, brought together entirely by chance and thus without any mutual connections, were presented in a card rack on the wall. Visitors could assemble and take with them their own sub-collection from this 'archive' which, in its never completed form, could be regarded as a mirror of contemporary culture ('Dutch culture' – even if, or actually *because*, Schmid included material from other countries as well). Schmid was radical in both his 'method' of collecting, primarily in the absence of any predetermined plan, and in choosing a sort of auteurship that he ultimately rejected. In the catalogue he wrote, 'You can do with it as you will. The moment that I publish the work it ceases to be mine.'

Here one cannot speak of the 'ultimate post-modern work', because according to the artist one cannot speak of a 'work' at all. In *Sinterklaas ziet alles* Schmid employed chance in a radical manner in order to obtain material from chaotic reality, transferring this material into a uniform and systematic card system, before returning it to that same reality again, so reducing it to chaos. This makes *Sinterklaas ziet alles* his most radical work to date – not only can it be regarded as a lively critique of the concept of the museum and of the distinction between high and low art around which the art market revolves, but also as an ironic game with his own artistic practice. Actually, there is only one additional, more radical step imaginable: Schmid sees a photograph lying on the street during one of his walks, but does not pick it up. Neither the walk, nor the photo, but only the grateful smile on his face is all that is left as 'the work'.

Translated from the Dutch by Don Mader.

2 This prestigious programme was called *PhotoWork(s) in Progress*, and was initiated by the Nederlands Foto Instituut and the Mondriaan Foundation as an incentive for thinking about the content of documentary photography in The Netherlands. The citation from Schmid comes from the catalogue involved.

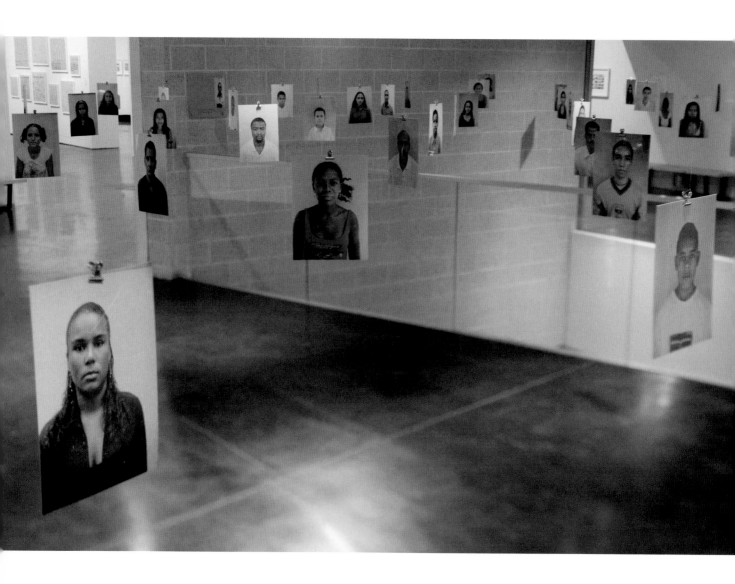

Belo Horizonte,
Praça Rui Barbosa

In 1992 Schmid was invited to Belo Horizonte, Brazil, to teach a short workshop on making art with found photographs. Upon introducing his ideas and discussing projects such as *Bilder von der Straße*, he was told by students that this was fine for affluent and image-rich countries like Germany, but it would not work in Brazil because it would be impossible to find discarded photographs there. To prove them wrong, he went on a walk through the city and gathered a range of photographic materials, including a set of black and white negatives gathered in a city square, Praça Rio Branco. Created by street photographers using crude equipment to provide cheap, while-you-wait ID photographs for the Brazilian working class, they formed the first of three collective portraits of Brazilians done by Schmid between 1992 and 2002. Each is named after the plaza where he found the negatives.

The Belo Horizonte projects all employ a similar methodology, presenting a large number of head shots arranged in a grid. The images themselves were taken by Brazilian street photographers in the most straightforward manner possible, with the subjects looking directly at the camera lens. Presumably they were done for government forms and job identification cards requiring a standard pose and relative lack of facial expression. Schmid noticed that all of the photographs from Praça Rio Branco depicted men and assumes that for some reason women either did not use the street photographers or went to another plaza to have their pictures taken. On later visits he was able to find photographs of both men and women.

The black and white photographs of *Belo Horizonte, Praça Rio Branco* were created with irregular black and white negatives cut individually from larger pieces of sheet film. The photographers processed the negatives on the spot in the small, light-proof box that also served as the camera. Reaching into the camera box through lightproof sleeves, they briefly rinsed and squeegeed the negatives before making a set of contact prints. Small pails in the box held the developer, water stop bath, and fixer. The box was then opened, the prints air-dried and given to the client, after which the negatives were discarded on the ground. According to Schmid, the photographers noticed that he was picking up the negatives and did not object.

In 1993, Schmid returned again to Brazil and collected another set of negatives, done this time on 120 roll film but still cut into individual frames. When he returned in 2002, the photographers had switched to 35mm cameras and had begun to use strips of colour film. They were processed in a nearby lab and the negatives were then thrown in the garbage, where Schmid was able to collect them on early morning raids.

The final Brazilian project, *Belo Horizonte, Praça Rui Barbosa*, includes two hundred and forty colour head shots, hung from the ceiling in a metre-square grid to fill the available gallery space. Suspended on monofilament, the faces are alive to movement in the air, turning slowly, as if to look at each other and at visitors moving through the photographic crowd. As with *Very Miscellaneous*, an accompanying artist's book functions as a second version of the piece. Its size mimics the passports and ID folders for which many of the images were originally intended.

The Brazilian projects embody attitudes central to Schmid's work as a whole. Modest in size, they display an economy of means that is both Schmid's own and that of the original photographers. Their expressive potency and quiet beauty argue that the huge scale and costly production values of today's art photographers are an unnecessary product of professional appetite and vanity, a gluttony of both the eye and pocketbook. Although large in number, Schmid's Brazilians don't seek to overwhelm viewers. The vantage point they offer is at heart egalitarian, grassroots, and democratic. We look at them, and they look back at us.
John S Weber

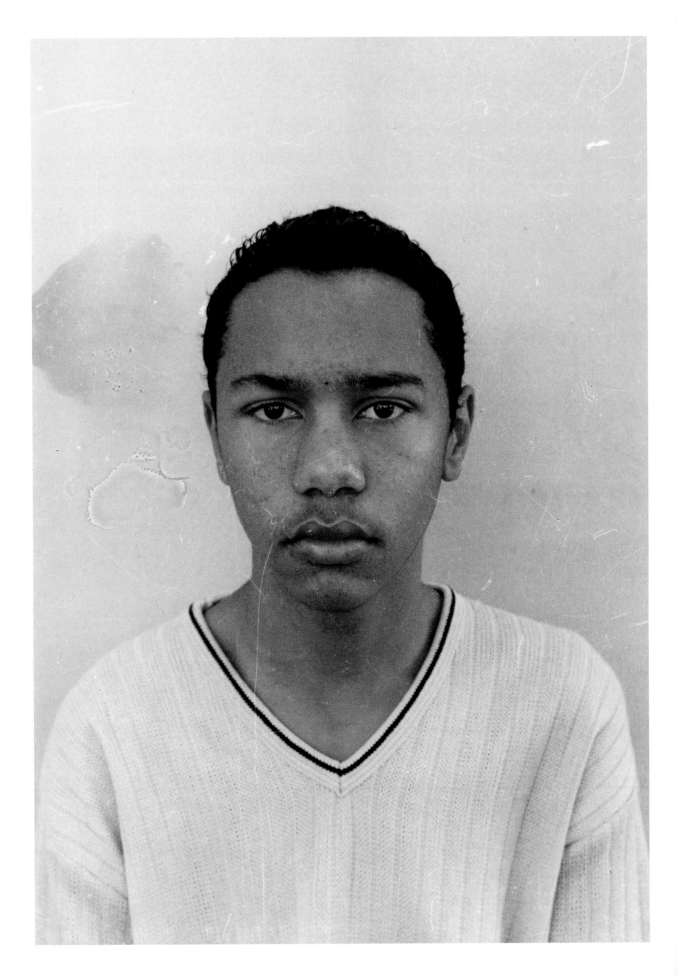

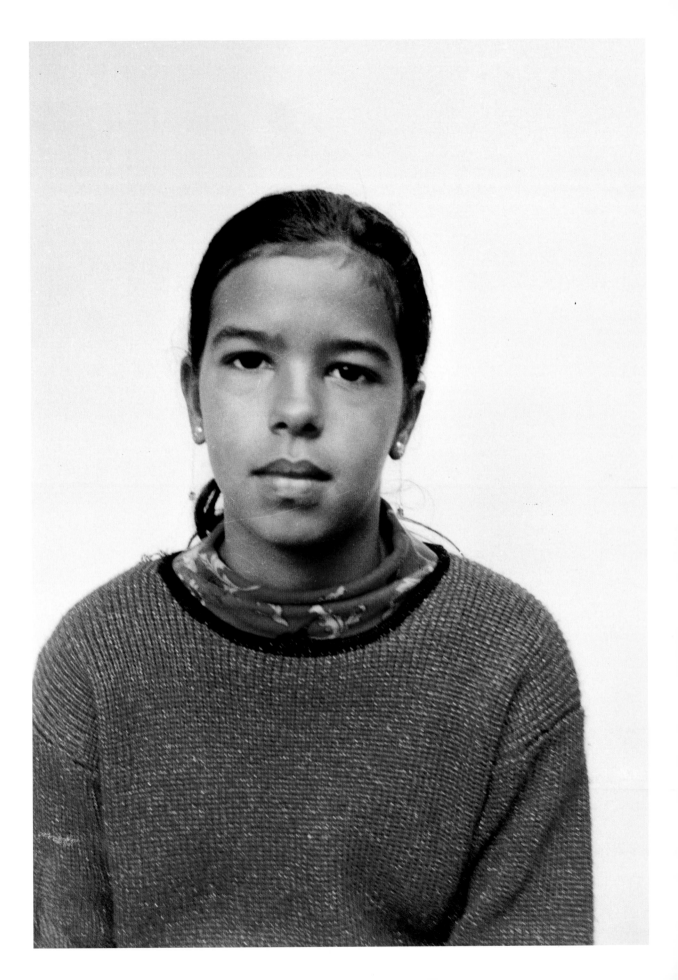

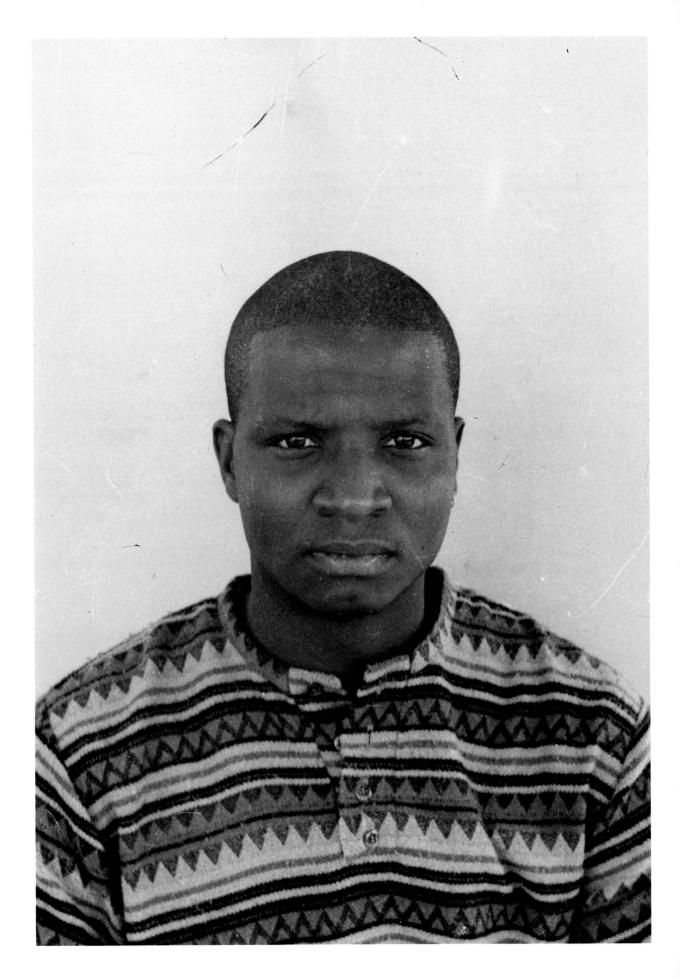

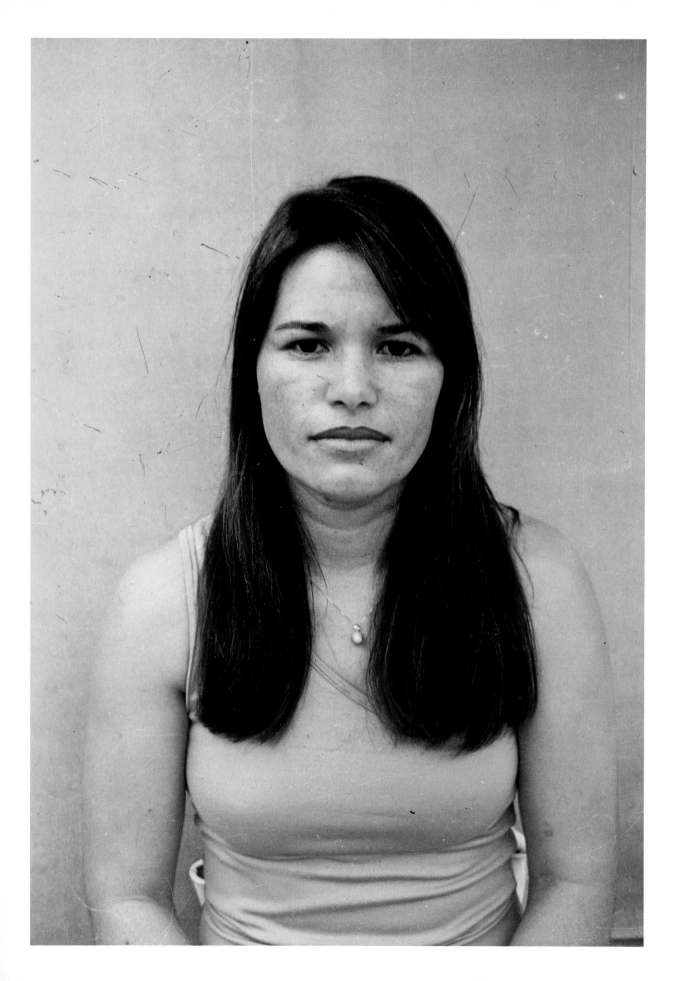

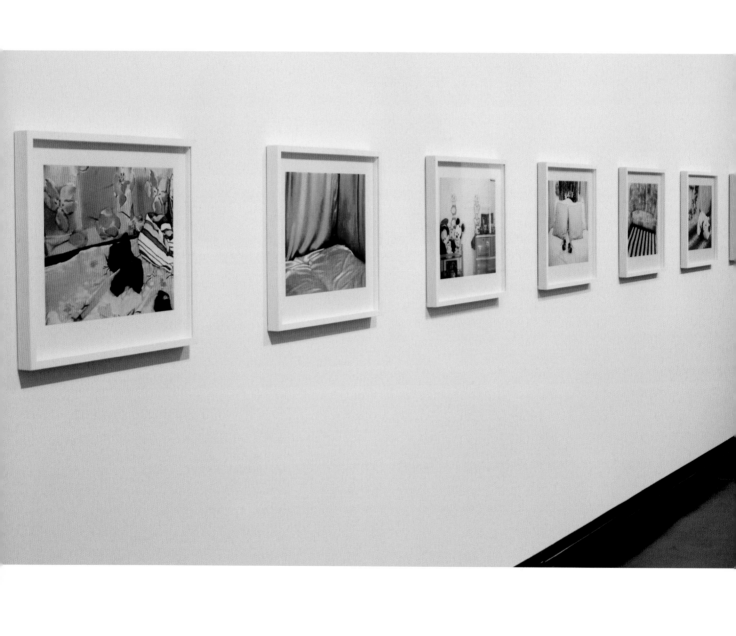

Cyberspaces

The lurid, low-res, pixelated blurriness shared by the photographs in *Cyberspaces* signals their origin as cheap digital images, in this case frame-grabs from internet webcams. Enlarged from a 240 x 320 pixel video stream, the available photographic information – barely usable to begin with – degrades and flattens out, unable to meet the demands of a 50 x 60cm Lambda print. Seen live, in full scale, the printed images look oversaturated, tacky, and weirdly beautiful. More than anything else Schmid has done, *Cyberspaces* look overtly like 'art' on first view. Bright colour lends the work a perky, ingratiating, even decorative air, but only until you get past the pixelated surface of these unnervingly evacuated, ultimately creepy scenes.

In *Cyberspace #35* a ridiculous stuffed-toy doggie with sad, pleading eyes peers up, looking out of the frame, crouched low on a tigerskin coverlet. The distorted colours are sickly and exaggerated, too pink, too purple, too orange, too yellow, and too much. He's looking up at someone but she, or he, or it, is off screen. What happens next is anyone's guess.

In *Cyberspace #10* a pair of six-inch stiletto heels is lying on a bed with pink sheets and pillows. A small green table holds an array of rocket-like dildos and vibrators, ready for action in front of a drape that might be fake leopard skin. It's hard to tell if the metallic, mechanical thing in the top left is a pair of handcuffs covered with raspberry-coloured fur, but it could be.

All of the images in *Cyberspaces* are from sexcams, but none of them are populated by the internet prostitutes whose working spaces they portray. Florid colours and low resolution initially lend the images an almost painterly, impressionistic quality that masks, briefly, what's really going on here. The vantage point is up close, only one or two metres away, and not much higher than the bed, chair, or couch. Stuffed animals appear repeatedly, unsettling companions and stand-ins for the young women we don't see. In one of these images, *Cyberspace #22*, you can make out a keyboard and a mouse at the bottom of the frame and imagine its owner returning soon.

Schmid began working on *Cyberspaces* at a time when health concerns forced him to pass much of his time indoors, spending what he characterises as 'too much time on the Internet.'[1] Sitting in front of a computer screen, he decided to make work about people doing what he was doing – namely sitting in front of a computer screen – as a way of questioning the nature of authentic experience in a virtual domain. Hunting for situations featuring people who sit in front of computers, he eventually arrived at 'people who do it professionally... for sexcams. The first one I entered, it just happened that the woman got up and left. I had a picture of an empty sofa, and I said, this is exactly what I'm hunting for.'[2]

Schmid finds the resulting images of empty stages a 'strange, sad document of what is happening throughout Eastern Europe and Southeast Asia, a huge industry where young girls sell themselves for small sums of money.... You look at the objects represented, and you get an idea about the age of the young women working there. Basically these are children's rooms.'[3]

John S Weber

1 Quoted on the artist's webpage, http://schmid.wordpress.com/works/2004-cyberspaces/.

2 Joachim Schmid, in a lecture at the Tang Museum, Skidmore College, 24 May 2006.

3 ibid.

Cyberspace 10, 2004

Cyberspace 35, 2004

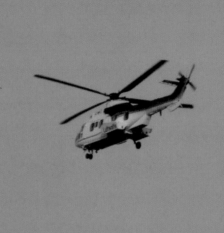

Tausend Himmel

Tausend Himmel consists of hundreds of images of the sky, shot with a digital camera at moments when the sound of helicopters overhead was audible from Schmid's Berlin apartment. The piece is displayed as an endless loop of colour photos fading from one to the next on a digital monitor or as a projection. At times the flying machines are present in the images; at other times not. Regardless, the photographs of *Tausend Himmel* are in part depictions of something that cannot be photographed, namely sound. The title, *Tausend Himmel*, can be translated as either 'Thousand Skies' or 'Thousand Heavens.'

This work is unique within Schmid's oeuvre and somewhat surprising, consisting as it does solely of photographs the artist has taken himself. Yet its methodology otherwise draws on practices common in Schmid's work. The random, reoccurring presence of sound in the sky functioned as a 'found' and non-authored trigger for shooting the photographs, much as the random appearance of photographs on the street motivated the structure and flow of *Bilder von der Straße*. In both cases, Schmid's self-imposed schema demanded that all of the photographs provided by the mechanism of the piece become part of the work and (when possible) exhibited as a body.

Tausend Himmel derives from a period in Schmid's life when he was suffering from hyperacusis, a hearing condition that deprives the brain of the capacity to regulate perceived sound volume in the head. For people dealing with this condition even soft sounds can be irritating, and loud noises are acutely painful. Living in a neighborhood which regularly attracted flyovers by government helicopters, Schmid was plagued by their noise. *Tausend Himmel* was his way of psychologically transforming a moment of discomfort into a welcome opportunity to pursue his work in a new way.

In formal terms, *Tausend Himmel* possesses a structure that is at once rigorous and open. It consists of a single image type that never repeats itself, offering a beauty that retains its pleasure and appeal regardless of how well we know it. In creating the pictures for *Tausend Himmel* Schmid attempted to shoot straight at the sound even when he was unable to see its source, and the resulting images display an unaffected compositional elegance that is gratifying in its simplicity. Photographs of helicopters and an occasional jet stream alternate with cloudscapes of every kind, addictive in their variations and transformations.

Schmid's multifarious cloudscapes inevitably call to mind Alfred Stieglitz's canonical *Equivalents*, but the comparison is ultimately beside the point: Schmid's work neither tries to carry the metaphorical and philosophical baggage Stieglitz was after, nor is the experience of viewing Schmid's cross-fade, full-colour, time-based piece anything like the act of peering at Stieglitz's series of small, framed and matted, black and white photos on a wall. In *Tausend Himmel* one is struck by the sky's routinely astonishing, unintentional beauty, its variety, and the jarring repeated sight of flying metal overhead. The absent presence of sound in the piece operates at a conceptual undertone – intriguing on an intellectual level but in the end a sidebar to the viewing experience itself.

At first glance, *Tausend Himmel* seems to mark a departure in Schmid's work. Certainly, it is debatable whether the images that make up the piece are really 'found photographs' in the strictest sense, regardless of how satisfying it may be as a work of art. After longer acquaintance the differences between *Tausend Himmel* and Schmid's other projects begin to recede, and its underlying conceptual framework, serial structure, and 'automatic' aspects link *Tausend Himmel* both formally and philosophically to the larger body of his work. The fact that the artist himself made the photographs remains the single remaining possible 'objection' to this piece – a curious and thought-provoking example of the larger issues raised so dramatically by Schmid's career as a whole.

John S Weber

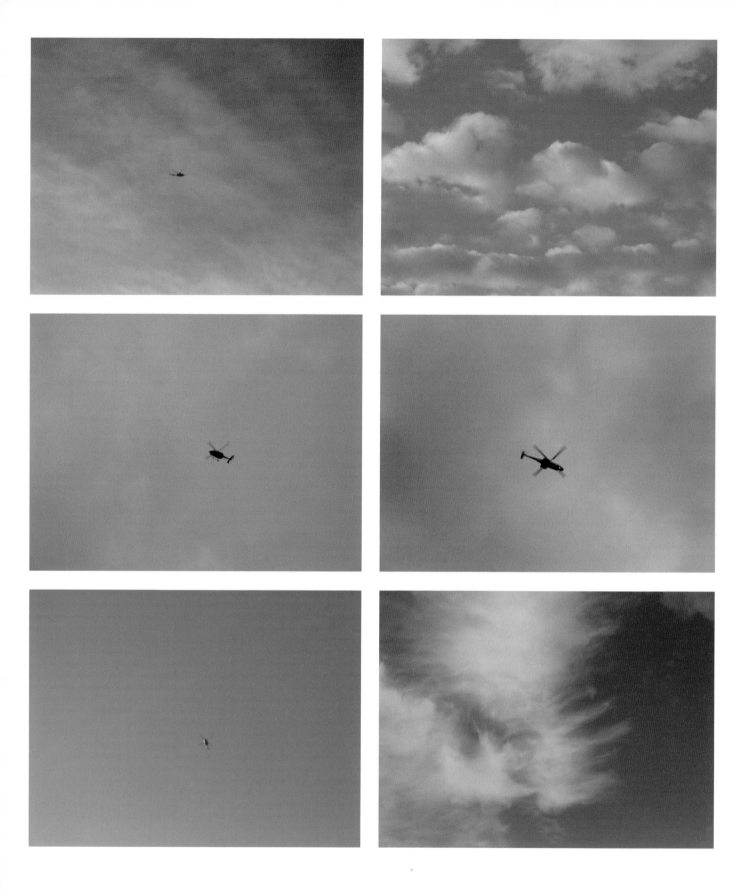

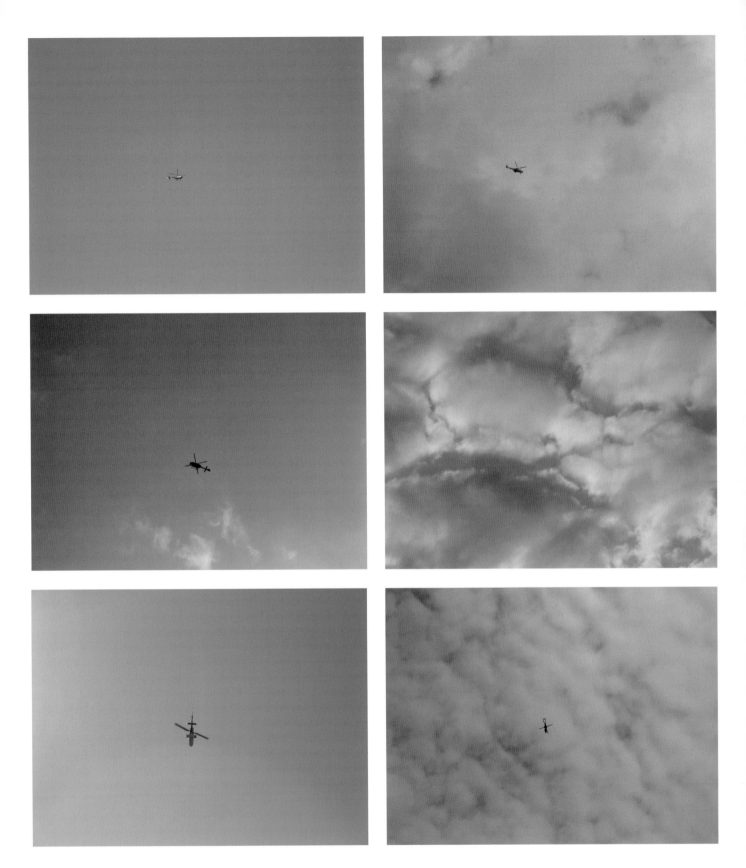

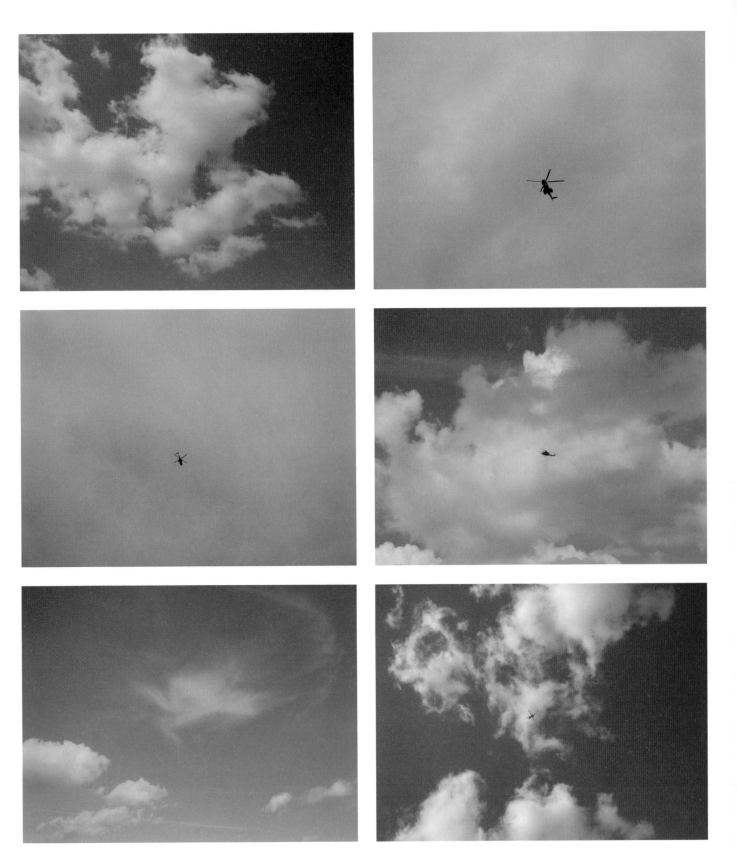

enkmodelle
ender Lan-
t Landes-
saufgaben
hofen un-
n Bieden-
ist schwer
will der
er im
enden zu
auch nur
ag defi-
onisse der
lgen ken-
er Partei
den Ein-
h laviert

n als der
en Verei-
vird aber
iern ver-
llvertre-
. Das hat
zwischen Linssen
, augen-
ern. Die
lso dem-
bereinan-
kopf dies
einem
die

Marita HAIBACH Foto Barbara Klemm

Kampf dem Sexismus

Als Marita Haibach vor drei Jahren,
damals noch unter dem Namen Hai-
bach-Walter, als Abgeordnete der Grü-
nen in den Hessischen Landtag einzog,
wurde sie sofort überall bekannt. Foto-
reporter und Fernsehen verbreiteten sie
als „Hemdenmatz", weil sie in Jeens
⸱⸱t lan üher d t

20

unzu-
eigen-
inhin
f sei-
gani-
aden.
gde-
rga-
bei
die
als
ung
e es
rung
ge es
ajahr
scher
n die
g ei-
scher
kom-
ßen-
Dop-
lehn-
l im
gde-
nisa-
alen"

den
ngen
oliti-
licht
hal-
. Im
⸱⸱a-

Claudio MARTELLI Foto dpa

Craxis Schildknappe

Lange Zeit konnten sich die Italiener
nur schwer daran gewöhnen, daß ein
junger Mann, ein gutaussehender Jüng-
ling mit Pausbacken und lockigem
Haar, an einer einflußreichen Stelle der
Politik in Rom saß. Claudio Martelli,
stellvertretender Sekretär der Soziali-
stischen Partei Italiens (PSI), verwur-
⸱te stets dur⸱ ⸱ndli⸱⸱
nd ⸱

21

Books

Through the first half of the 1980s, Schmid perceived his work primarily as criticism and publishing, including periodic critical essays for *European Photography* and the editing, production, and writing for his own journal, *Fotokritik*. He had already started collecting the found street photographs and fleamarket snapshots that would form the bases of *Bilder von der Straße* and *Archiv*, but it was not yet clear to Schmid precisely how he would use them. Functioning in part as an amateur archeologist and in part as a critic, he was also assembling other groups of photographs about photography from the popular press. In some cases, these served as the subject matter for analytical essays in *Fotokritik*, his own journal, or for his regular essays in *European Photography*. Upon ceasing publication of *Fotokritik* in 1987, he began drawing on some of this material to self-publish books, starting in 1988 under the auspices of Edition Fricke & Schmid, founded with his friend, the artist Adib Fricke.

Created by hand in editions of fifty to four hundred, publications such as *Der Leser hat das Bild* [The Reader Has the Picture], *Faits Divers* [Miscellaneous News], and *Phantome* [Phantoms] function both as short-run, artist's books and as visual essays on the uses and sociology of photography. At the time he began making them, Schmid had curtailed his critical writing, convinced that simply presenting the material itself was more interesting than whatever he might still have to say about it. Speaking of this moment, Schmid refers to a celebrated comment made by artist Gerhard Richter about his painting, 'My pictures are smarter than I am.'[1] Quantity, Schmid also realised, could add up to quality. A critical mass of sufficiently related photographic material, presented on its own, would operate both as subject matter and as an implicit meta-critique of it. Whether the result was precisely art or not was, at this point, still only of marginal interest to Schmid.

The earliest books, such as *Der Leser hat das Bild*, were produced much like zines, using photocopy reproduction technology and simple binding done by Schmid himself. Editions of fifty were sold at Printed Matter in New York and a few bookshops in Germany, typically selling out after a few years. Realising this, Schmid invested in commercial printing and binding for the later books, such as *Erste allgemeine Altfotosammlung* and *Kunst gegen Essen* [Art for Food].[2]

Errata
Edition Fricke & Schmid,
Berlin, 1989

1 In conversation with the author, 24-26 May 2006. Richter's original German, 'Meine Bilder sind klüger als ich', is also the title of a documentary about the painter.

2 The title, 'Kunst gegen Essen', is a pun in German that can mean both 'art in exchange for food' and 'art against food'.

Regardless of whether they were made by hand or machine, Schmid's books share a spare, no-fuss aesthetic that is deliberately removed from the preciousness of many short-run, expensively produced artist's books. They are small in size, and focused in theme. Some were published as catalogues for exhibitions, others function simply as an inexpensive, democratic method of distributing images and ideas about them. Generally they deal with photography in the press, advertising, and commercial realms, and frequently they are funny in a sardonic, dry manner.

The curious photos in *Faits Divers*, for example, were all drawn from the boulevard newspaper *BZ* and feature barely legible scenes that illustrate peculiar, deadpan captions such as 'Japanese place a high value on bowing correctly,' '95 percent of the land is desert,' 'A police dog relaxes on his master's leash,' and 'Danger threatens the sphinx'. At a time when theory-driven image-text work had been rampant for over a decade in the art world, Schmid's found photo+caption couplets served as purloined readymades. They operate as a real-world, found critique of how intersections of text and photos create meaning, while pointing out the surreal weirdness of his mass culture raw material.

Der Leser hat das Bild, drawn from a regular feature of the same name in the *BZ*, features 'reader photographs' sent to the paper with short, invariably naïve titles and commentaries about where and why they were taken. Many were sent in response to recently published articles, as part of pleas to locate missing relatives, or simply to share vacation pictures. Anticipating the participatory blog-culture that appeared on the internet a decade and a half later, they document photographic culture at its most personal, banal, and direct. A picture of a cat in a bathtub is titled 'The most beautiful photo of my Water-Cat!' A daylight photo of a balcony filled with flower pots reads, 'When it gets dark I illuminate my 7 metre long balcony with chains of lights.' A photo showing a man with his arm around a once famous German actress proclaims, 'Marina and Rudi: A photo that I took 40 years ago.'

In the past decade, Schmid has produced a number of small books such as *Very Miscellaneous* and *Belo Horizonte, Praça Rui Barbosa* to function both as catalogues and as artist's books in their own right. Funded as part of related exhibitions, they remain inexpensive to purchase – an important issue for Schmid – despite higher production values. In scale and approach, they retain much of the feel of his earlier handmade artist's books. The eccentricity of their small size lends them a somewhat gem-like aura and allows them to be easily slid into a jacket pocket or purse.

The most outwardly 'normal' book Schmid has produced to date is perhaps *Erste allgemeine Altfotosammlung*, [The First General Collection of Used Photographs], a spare, sixty-four page narrative about the art initiative of the same name. It tells the surprising and often hilarious story of how a small joke for the photo world turned into a major source of photographic raw material and an even more intriguing conceptual art project. Although not an artwork in its own right, the book, by chronicling the *Altfotosammlung's* surprising trajectory, serves much the same function as photographs of performance art. It describes a sequence of past events in sufficient detail to allow the piece to be imagined, thereby calling it into being as an artwork and historical event.

Schmid's production of books charts the evolution of his practice from critic-archeologist to artist more precisely than any other aspect of his work. Like his installations and serial photo projects, the books rely on close observation of photographic phenomena, an accumulation of small gestures, and modest physical means. Their scale and economy allows them to be sold inexpensively, underlining the thoroughly anti-monumental, philosophically egalitarian attitude running through Schmid's work as a whole.
John S Weber

**Auf die richtige Verbeugung le-
gen Japaner großen Wert**

Faits divers
Edition Fricke & Schmid,
Berlin, 1989

**Angestellter:
Levon Sedefyan**

Porträts
Edition Fricke & Schmid,
Berlin, 1989

Porträts

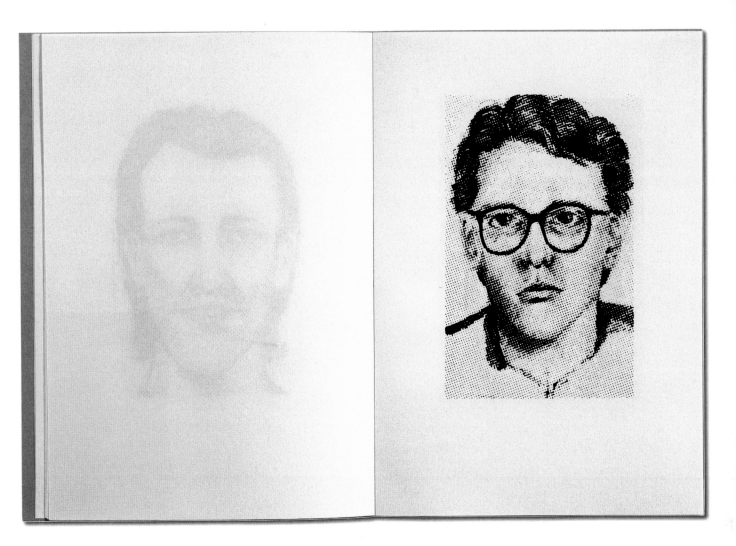

Phantome
Edition Fricke & Schmid,
Berlin, 1992

Phantome

Bitte fordern Sie unseren Gesamtprospekt an, falls Sie an weiteren
Veröffentlichungen der Edition Fricke & Schmid interessiert sind.

Erste allgemeine Altfotosammlung
Edition Fricke & Schmid,
Berlin, 1991

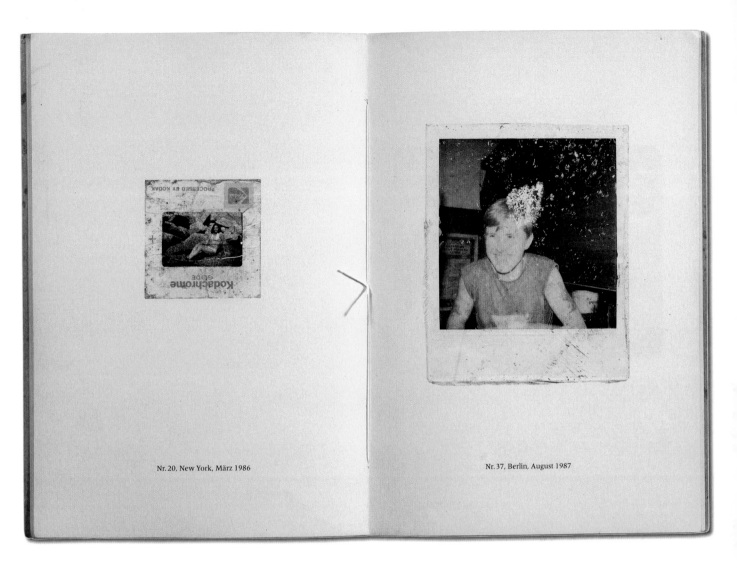

Nr. 20, New York, März 1986

Nr. 37, Berlin, August 1987

Bilder von der Straße
Edition Fricke & Schmid,
Berlin, 1994

Archiv #670, 1996

Archiv #662, 1996

Kunst gegen Essen
Edition Fricke & Schmid,
Berlin, 1996

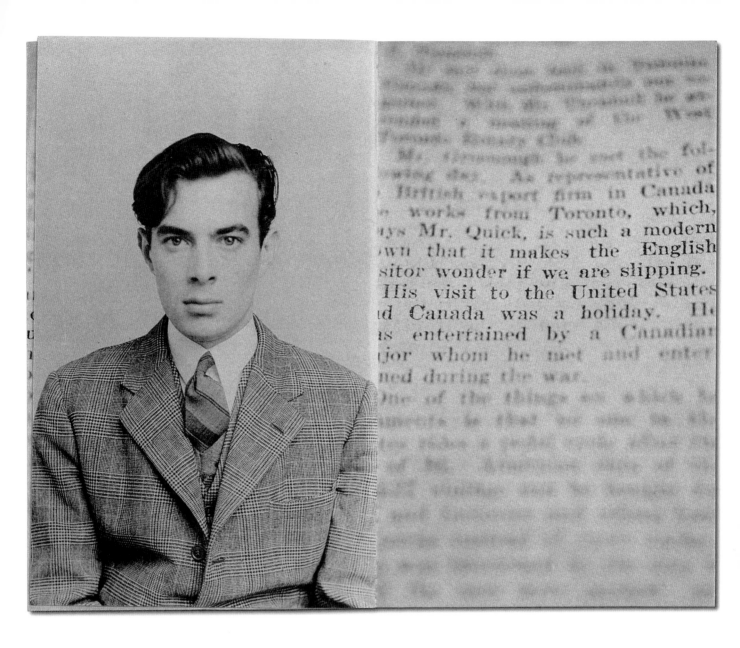

Very Miscellaneous
Photoworks,
Maidstone, 1997

A 45-YEAR-OLD mother cried last night when she was told that her daughter, who has been unconscious in hospital for nearly three years, has been awarded £18,279 damages.

Then she said: "I would give every penny, even if it were 10 times as much, just to hear her say: 'Hello, mother.'"

Mrs. Ada Wise glanced round her council house and sighed: "All that money! But in some ways it is meaningless to me.

"My heart is too full of sadness for me to think of what my husband and I will do with it."

HEAD-ON

As she was talking at her home in Great Milton, near Oxford, 22-year-old daughter Veronica—the Sleeping Beauty —was still unconscious in a hospital not far away.

She has been there ever since she was injured in a road accident 987 days ago.

Veronica was in a car driven

HERALD REPORTER

by her 24-year-old brother Robert Wise which crashed head-on with a van driven by John Kaye, of Silver-street, Edmonton.

Yesterday, at Oxfordshire Assizes, Veronica, through her father 48-year-old electrician Frank Wise sued both men for damages.

Mr. E. W. Eveleigh, for both defendants, said that there was no dispute about liability because they had the same insurance company. But they both denied they were negligent.

Mr. Justice Finnemore said that the accident had reduced Veronica to "a living death."

He awarded her £15,000 for the loss of the amenities of life, £2,000 for loss of earnings, and £400 for shortened expectation of life. Special damages of £879 had already been agreed.

The money will be administered by a county court. The judge granted a 21-day stay of execution pending an appeal.

The night that the car crashed Veronica, her fiance, her brother and another man;

had been celebrating a girl's 21st birthday.

All five were injured. Only Veronica did not recover.

Six months ago Veronica's fiance, 23-year-old aircraftman Colin Slaymaker, whose home is in the neighbouring village of Great Haseley, broke off the engagement with the consent of her family.

Every day since the crash one member of the family has gone to visit Veronica, hoping that she might show a spark of life.

Yesterday it was Bob's turn. For a long time after the crash he and his family had a disagreement.

BITTER

For when Bob took his sister out in the car on the night of the crash it was against his father's wishes.

Mrs. Wise said: "Naturally, my husband felt a little bitter towards Bob at first, but he has forgiven him now."

None of the family was in court to hear the award made.

Last night Veronica was still asleep. Now she may never know that she has a small fortune.

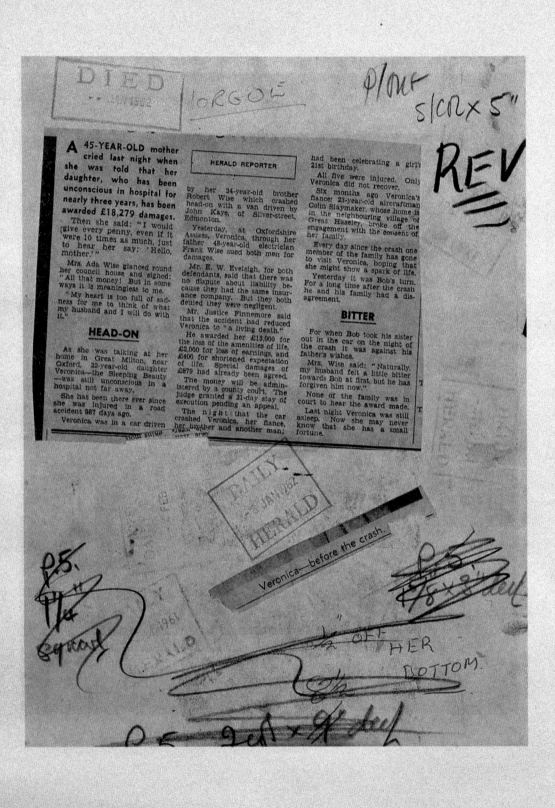

Veronica—before the crash.

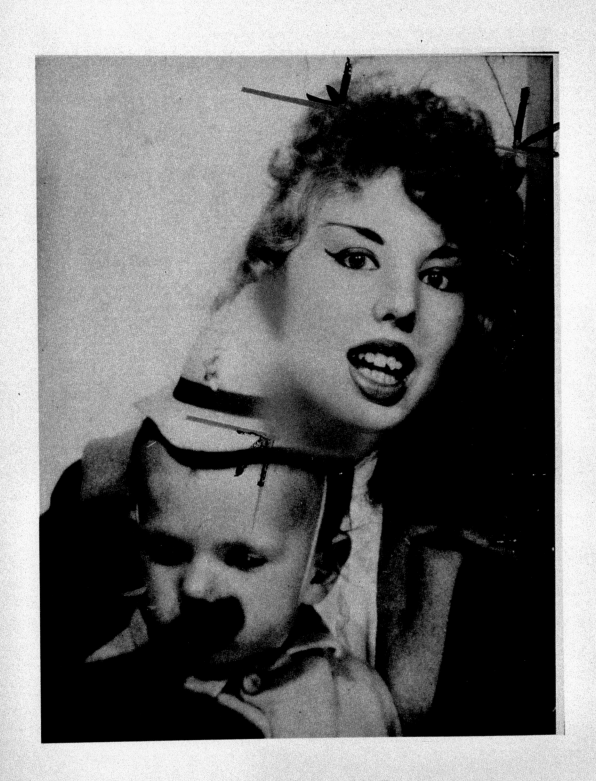

Joachim Schmid

Sinterklaas ziet alles

PhotoWork(s) in Progress

p280|281: *The Face in the Desert*
National Museum of
Photography, Bradford, 1999

Sinterklaas ziet alles
Nederlands Foto Instituut,
Rotterdam, 1998

After even good friends, ones whose opinions I can usually trust, began to spin fantastic tales about the internet, I decided that it was time to, at the very least, take a look. I had nothing more to lose than vague aversions. Alternately, my prejudices would finally have a firm foundation. So off to the village and colleague F's net party. I saw and read a considerable amount in the course of a few hours; they were either things that I already knew (practically all of them miserably edited) or things which really didn't interest me at all. There was nothing surprising except for fascinating design (and I had really expected that). In one of the — and now I'm missing the correct noun — is it lines, pipes? Let's just say — set ups inviting you to gab I left behind an anecdote related by friends in Seattle — which promptly disappeared from the screen: Their son developed a real interest in the bees constantly buzzing through the garden. He quickly hit upon the idea of keeping such useful beasts himself. In-depth literature on this topic could not be found in the city library, and the biology teacher couldn't offer any further assistance. In the internet, however, the boy discovered a means of contacting his future beekeeping colleagues. Within mere hours after having left his address in the net the doorbell rang. It was the lady from next door who happened to have had a beehive in her garden for years.

Berlin, January 24, 1996

Rotterdam, August 5, 1997

Enschede, August 1, 1997

Rotterdam, July 26, 1997

Rotterdam, June 12, 1997

London, May 5, 1998

Berlin, December 27, 1996

A young man with a backpack in the train between Enschede and Amersfoort: "Holland, oh boy, tell me one reason why you want to stay in Holland! It's a damned country ... You should go to Ireland ... Here, look at this: one city next to the other, streets, railway tracks, canals, bridges, ditches, fences ... no space, really, you cannot walk anywhere ... and have you ever seen that incredible airport? The smallest country has the largest airport ... it's totally fucked up ... people everywhere, wherever you go to ... too many people, too many cities ... you cannot walk anywhere, absolutely no space, nowhere ... I'm going to fly to Dublin tonight; Ireland, that's a country! Why do you want to stay here! This is a damned country ... I'm leaving to see my girlfriend tonight, a lovely woman, beautiful Irish girl ..."

Amersfoort, August 1, 1997

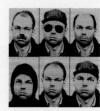

Berlin, January 12, 1998

Rotterdam, September 13, 1997

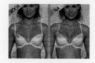

Breda, September 7, 1997

In addition to the bus tours that not only take you through the city, but also to the windmills, tulips, and cheese market, the tourism companies regularly organize an evening walking tour *Amsterdam by Night*. A small group gathers at a meeting point, married couples and lone travelers, everyone a bit unsure and shy. They want to see the "legendary" *Red Light District*. The multilingual guide tries to act relaxed and first assures his clientele that the outing is completely safe as long as you follow the rules; the only rule apparently being not to take pictures of the prostitutes. The group walks through the district for about two hours, occasionally stopping and observing as the guide directs. The explanations are as banal, as they are routinized, garnished again and again with the same slightly suggestive little jokes about mothers-in-law, with a wee wink for the gentlemen, but without becoming really uncomfortable for the ladies. The man could sell used sports cars in a suburb; during today's window-shopping expedition in the red light district he relates a bit of the city's history in passing. We can look with a good consciousness because, after all, we've paid for it. To cap off the official program everyone meets in the same pub that the other guides herd their groups into (a drink is included in the price of the tour). Our specialist chats about this and that in the relaxed atmosphere, but preferably about himself; he really used to be a car salesman — and one of his customers was really a librarian.

Amsterdam, September 10, 1997

A meeting on holiday
By Joachim Schmid for the NEROC'VGM Meetings series

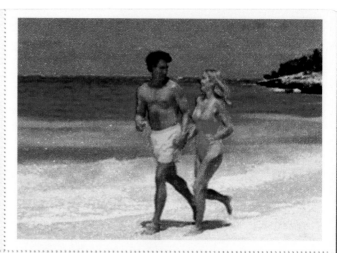

A meeting on holiday
By Joachim Schmid for the NEROC'VGM Meetings series

A meeting on holiday
Neroc'VGM in collaboration
with KesselsKramer,
Amsterdam, 2003

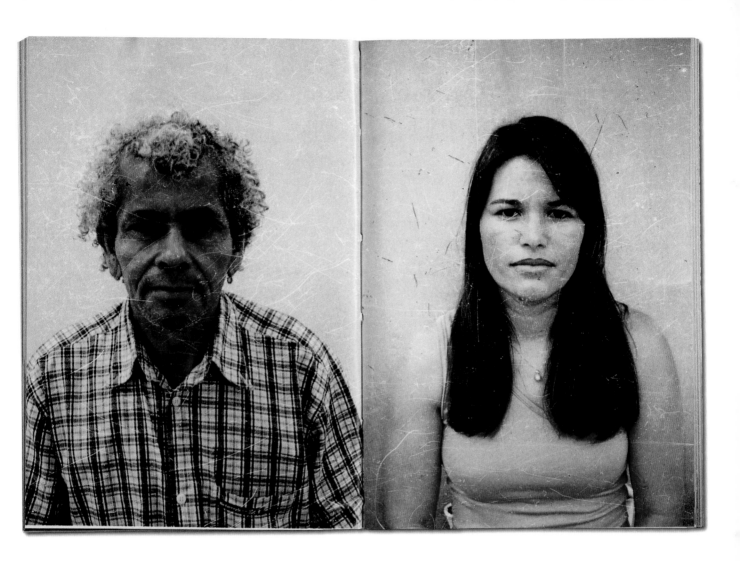

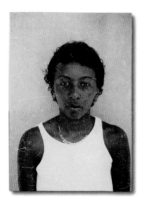

Belo Horizonte, Praça Rui Barbosa
self-published,
Berlin, 2004

Installation views, Tang Museum,
Skidmore College, 2007.

Artist's Acknowledgments

I would like to thank everybody who was involved in the creation of the exhibition and the book, first of all John S Weber who initiated this project. My thanks to him and the other authors Stephen Bull, Joan Fontcuberta, Frits Gierstberg, Jan-Erik Lundström, and Val Williams for their insightful and original essays. I enjoyed them and they gave me a number of new ideas. Thanks to everybody working with John at the Tang Museum, thanks to Stefanie Braun and her colleagues at The Photographers' Gallery, to Frits and the staff at Nederlands Fotomuseum, and to Katarina Pierre and Jan-Erik, BildMuseet, Umeå. Thanks to Gordon MacDonald and everybody working with him at Photoworks, to Dean Pavitt for the book design and to everybody at Steidl for their professional work.

I feel most obliged to the Andy Warhol Foundation for the Visual Arts for their support of this book.

Very special thanks to Angelika who has been the most supportive friend for many years.

Biographies

Joachim Schmid lives and works in Berlin. He has exhibited internationally since the late 1980s and his work is held in many major museum collections including the Museum Folkwang, Essen; the Stedelijk Museum, Amsterdam; the Nederlands Fotomuseum, Rotterdam; the San Francisco Museum of Modern Art; the Maison Européenne de la Photographie, Paris and the Daelim Contemporary Art Museum, Seoul. Schmid's work has been the subject of nearly twenty artist's books including *Phantome* (1992); *Bilder von der Straße* (1994); *Very Miscellaneous* (1997) and *The Face in the Desert* (1999).

John S Weber is a writer and Dayton Director of the Frances Young Tang Teaching Museum and Art Gallery, Skidmore College, Saratoga Springs.

Gordon MacDonald is an artist, curator, Editor of Photoworks magazine and Project Manager of Photoworks, Brighton, England.

Stephen Bull is an artist, writer and lecturer based in Brighton, England. He is Course Leader for BA (Hons) Photography at The University of Portsmouth.

Joan Fontcuberta is an artist, writer and critic, living and working in Barcelona.

Frits Gierstberg is Head of Exhibitions at the Nederlands Fotomuseum, Rotterdam.

Jan-Erik Lundström is a photographic historian and Director of the BildMuseet in Umeå, Sweden.

Val Williams is a writer, curator and Director of the Photography and the Archive Research Centre at the London College of Communication.